NORTH SOMERSET LIBRARIES
WITHDRAWN AND OFFERED
FOR SALE
ALL ITEMS SOLD AS SEEN.

NSWS

Please return/renew this item by the last date shown
on this label, or on your self-service receipt.

To renew this item, visit **www.librarieswest.org.uk**
or contact your library

Your borrower number and PIN are required.

Libraries**West**

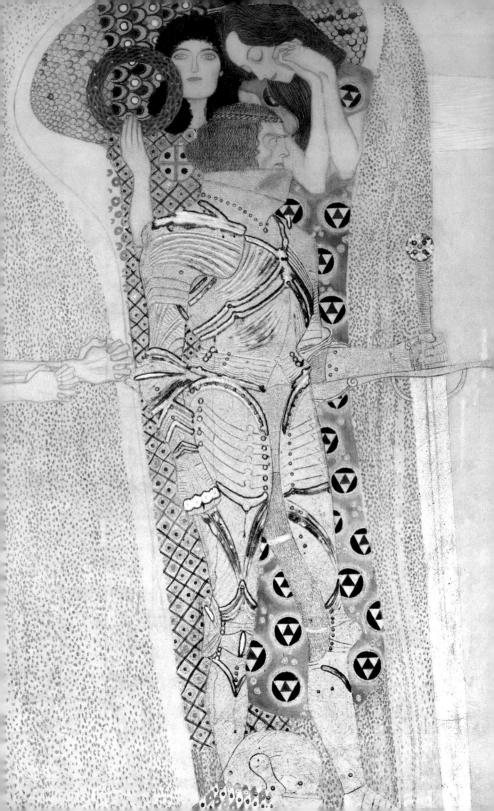

ART ESSENTIALS

KEY MOMENTS IN ART

—

LEE
CHESHIRE

—

Thames & Hudson

CONTENTS

INTRODUCTION

Past events can seem as if they were inevitable. The future is uncertain, the present still to be properly understood, but because we know what did happen, it is tempting to think that it was always going to. The neat progression of artistic developments we find in books today was not preordained. Artworks we love now were not waiting to be found. Someone at some point had to make a decision, a choice. They had to take an action that could never have just happened.

This book revisits fifty days from the last 500 years or so when something happened that changed the course of western art: when now world-famous artworks – such as Michelangelo's *David* or Marcel Duchamp's urinal – were unveiled for the first time; when chance meetings spurred artists to create exciting new styles, such as Impressionism or Cubism; when landmark performances took place, or revolutionary exhibitions opened. We will also look at fights, lawsuits, auctions and thefts – from the time the *Mona Lisa* was stolen to the day Vincent van Gogh's *Portrait of Dr Gachet* became the most expensive painting ever sold.

Some of these events were carefully planned. For example, the publication of the Futurist manifesto on the front page of the French newspaper *Le Figaro* on 20 February 1909 was part of an elaborate scheme to found a new art movement. Others were accidental: merely good or bad luck, just some of the many random events that shape all our lives. What unites them is how they have changed the way we think about art.

Of course, no event happens in isolation. Each is part of an infinite chain of cause and effect. This book could easily feature 500 days or 50,000. But the key moments we have picked here are some of the most memorable or influential in western art history and each provides a representative insight into an important artist, movement or theme. They provide a time-hopping guide to the people and places that shaped art. And all of them are great stories.

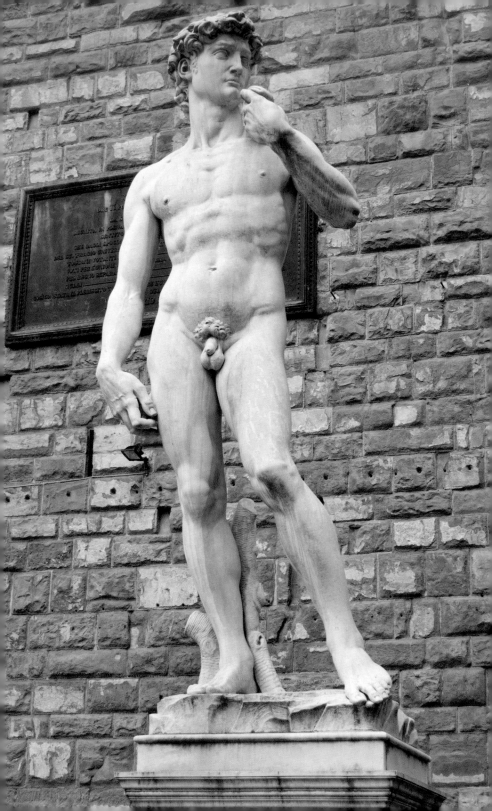

RENAISSANCE

-

Men of lofty genius sometimes accomplish the most
when they work the least, seeking out inventions
with the mind, and forming those perfect ideas which
the hands afterwards express and reproduce from the
images already conceived in the brain

-

Leonardo da Vinci

c.1495

CIMABUE FINDS THE YOUNG GIOTTO DRAWING ON A ROCK
c.1270s, A VILLAGE NEAR FLORENCE, ITALY

Cimabue was a renowned medieval painter who lived in Florence. One day when Cimabue was travelling to Vespignano, a nearby village, he came across a ten-year-old shepherd boy. While tending his sheep, the boy felt compelled to draw them, using a sharp stone on a flatter one. Cimabue was astounded by the shepherd's untaught talent and asked him to become his apprentice. In time, the boy Giotto surpassed his master and is now considered to be the first great painter of the Italian Renaissance.

This tale is told in Giorgio Vasari's *Lives of the Artists*, written nearly three hundred years later. Although modern-day scholars now doubt whether it actually happened, this story demonstrates the importance of these two artists to the development of the Italian Renaissance.

Vasari was the first writer since ancient times to collect together biographical information about painters, sculptors and architects. Instead of the largely anonymous craftsmen of the medieval period, Vasari presents artists as individual geniuses. He starts his book with Cimabue, who is considered to have perfected what Vasari calls the 'Greek' style and achieved great success and fame in his own time. However, Cimabue's achievements were eclipsed by Giotto's and few of Cimabue's works are still known.

The story of Giotto drawing on the rocks is also important because Vasari credited Giotto with 'introducing the technique of drawing accurately from life, which had been neglected for more than two hundred years'. Giotto's paintings certainly have a new naturalism. The people look like individuals rather than archetypes and the emotions of his scenes are clearly but subtly communicated. Giotto pioneered more complex compositions, for example, with figures with their backs to us (opposite, above) or walking off the edge of the painting. In this, he was an important influence on generations of artists to come.

Giotto
The Betrayal (The Kiss of Judas), c.1303–5
Fresco, this panel: 200 x 185 cm (17¾ x 72⅞ in.)
Scrovegni (Arena) Chapel, Padua

Giotto's most famous and important work is this fresco cycle for a private chapel in Padua, depicting the life of Christ and the Last Judgement.

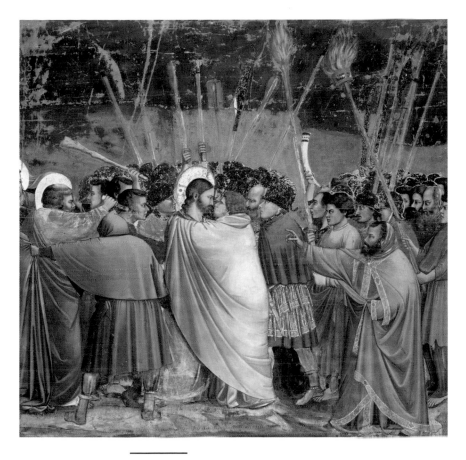

KEY ARTISTS

Cimabue (c.1240–1302), Italy
Giotto (c.1267–1337), Italy

KEY ARTWORKS

Giotto's frescoes in the Scrovegni Chapel, c.1305, Padua, Italy

CONNECTED EVENTS

9 January 1305 – The monks of a monastery in Padua complain
to their bishop about the Scrovegni Chapel, decorated with
frescoes by Giotto. They were probably offended by its excessive
pomp and splendour.

19 July 1334 – The first stone of the bell tower of Florence
Cathedral is laid to the designs of Giotto, who had been
appointed as chief architect. He dies three years later before
it is finished.

GHIBERTI WINS THE COMPETITION TO MAKE DOORS FOR FLORENCE BAPTISTERY
1401, FLORENCE, ITALY

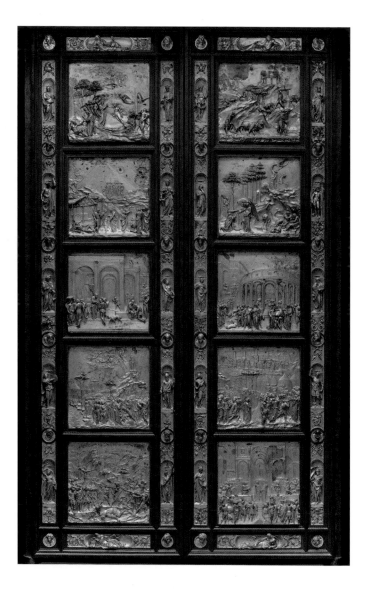

Lorenzo Ghiberti
Gates of Paradise, east
doors of the Baptistery of
San Giovanni (after 2012
restoration), 1425–52
Bronze and gilt bronze,
frame. 5.06 x 2.07 m
(16⅝ x 9⅛ ft)
Museo dell'Opera del
Duomo, Florence

**Ghiberti started on
his two sets of doors
(north and east) for
the Baptistery of San
Giovanni in his early
twenties and was nearly
eighty years old by the
time he finished them.**

Lorenzo Ghiberti was a young sculptor living in Rimini, on the
east coast of Italy, when news came to him that there was to be
a competition in Florence to find a sculptor to create spectacular
new doors for the Baptistery of San Giovanni.

The octagonal baptistery was an important early building situated
in front of Florence Cathedral. It already had a grand set of doors
with bronze panels by Andrea Pisano depicting the life of John the
Baptist. But in 1401 the wealthy guild of cloth merchants decided
to commission a new set of doors to mark Florence's 'miraculous'
deliverance from the plague. This was to be a serious undertaking:
the large amount of bronze needed would be extremely expensive
and it would require the establishment of a large studio with lots of
assistants. To ensure they got the best artist for the job, the guild
decided to hold a competition.

Seven artists were shortlisted, including Ghiberti (who was
only twenty-three years old), Filippo Brunelleschi and Donatello.
They were each given a year to create a sample piece showing the
biblical story of the Sacrifice of Isaac. The finished samples were
then assessed by a panel of sculptors, painters and goldsmiths.
(The sample panels made by Ghiberti and Brunelleschi still exist
and can be seen in the Bargello Museum in Florence.)

Different accounts relate slightly different outcomes, although
all agree that the judges found it hard to pick the best. In Giorgio
Vasari's *Lives of the Artists*, Donatello and Brunelleschi decide to gift
Ghiberti the commission, reasoning:

That [Ghiberti] being a young man . . . would be able to produce
by this exercise of his profession those greater fruits that
were foreshadowed by the beautiful scene which he, in their
judgement, had executed more excellently than the others;
saying that there would have been more sign of envy in taking
it from him, than there was justice in giving it to him.

In his autobiography, Ghiberti claims he won without 'a single
dissenting voice'; other versions have Brunelleschi being declared
joint winner but then heading to Rome in a sulk.

This first set of doors depicting the life of Christ, now positioned
on the north side of the baptistery, took Ghiberti twenty-one years
to complete and contains twenty-eight panels. In making them he
became one of the most influential artists in Italy.

After these doors were completed, he was given a second
commission: for the doors on the east side of the baptistery.
These took another twenty-seven years but surpassed his previous

work and set new standards for realism in sculpture, with the figures' accurately modelled proportions and the skilful depiction of buildings using linear perspective (see page 17). While the first doors' panels were constrained by the medieval 'quatrefoil' shape (opposite, below), in the second set of doors, Ghiberti used the entire square frame and reduced the number of panels to ten, allowing for more complicated and expressive compositions. They were widely admired as artworks that seemed to equal and surpass the achievements of the ancient world. Michelangelo is said to have given the panels their popular name when he was asked what he thought of them: 'They are so beautiful that they would do well for the gates of Paradise.'

Filippo Brunelleschi (below) and Lorenzo Ghiberti (opposite)
The Sacrifice of Isaac, 1401 Bronze, each 41 x 38.5 cm (16⅛ x 15⅛ in.) The Bargello Museum, Florence

Ghiberti's winning submission for the competition to design the Florence Baptistery doors (opposite) beat those by Brunelleschi and five others.

KEY ARTISTS

Lorenzo Ghiberti (1378–1455), Italy
Filippo Brunelleschi (1377–1446), Italy
Donatello (c.1386–1466), Italy

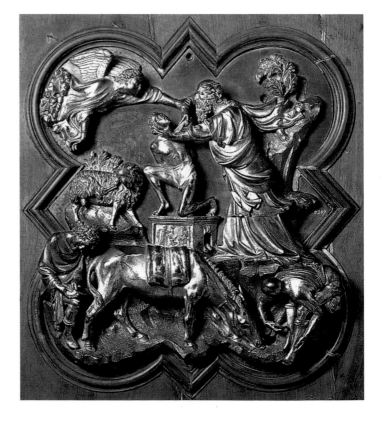

KEY ARTWORKS

Lorenzo Ghiberti, *The Sacrifice of Isaac*, 1401, The Bargello
Museum, Florence, Italy

Lorenzo Ghiberti, north doors of the Baptistery of San Giovanni,
1401–24, Florence, Italy

Lorenzo Ghiberti, *Gates of Paradise,* east doors of the Baptistery
of San Giovanni, 1425–52, Florence, Italy

CONNECTED EVENTS

1418 – Brunelleschi beats Ghiberti in a competition to design
the dome of Florence Cathedral. The city fathers doubt
Brunelleschi's plan to raise the dome without a large amount
of scaffolding. He challenges the other architects to stand an
egg up on its end. They cannot do it; Brunelleschi, laughing,
smashes one end against a flat piece of marble. The other
architects protest they could have done the same; he replies
they could have built the dome had they known his plans.

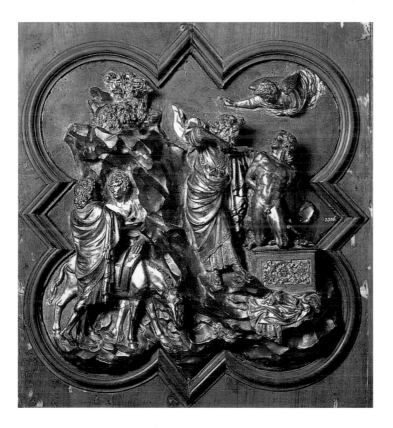

BRUNELLESCHI DEMONSTRATES LINEAR PERSPECTIVE
c.1413, FLORENCE, ITALY

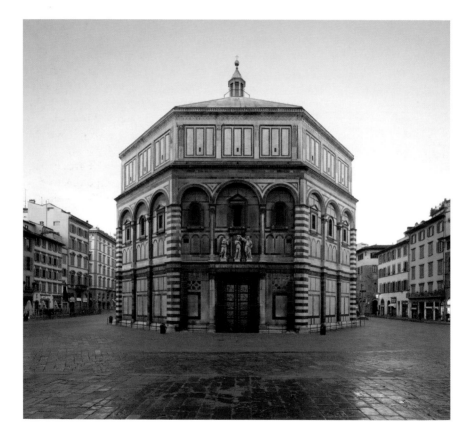

Opposite:
Unknown architect
Baptistery of
San Giovanni,
consecrated 1059
Florence

Brunelleschi made a
painting (now lost) of this
view from the porch of
Florence Cathedral.

Below: Leon
Battista Alberti
Diagram showing the
vanishing point from
Della pittura, 1436

Alberti's painting
manual *Della pittura*
(*On Painting*) helped
explain and popularize
the concept of linear
perspective.

Perhaps the most important artistic discovery of the Renaissance
was linear perspective – the method of accurately depicting
three-dimensional objects on a flat surface.

Medieval painters tended to depict figures almost like paper
cut-outs, sometimes within crude and awkwardly depicted buildings.
That changed one day in the early fifteenth century. The artist and
polymath Filippo Brunelleschi – best known today for designing
the dome of Florence Cathedral – set up an unprecedented
experiment in the cathedral's doorway. He faced the Baptistery
of San Giovanni, which sits across the piazza, and painted it using a
single vanishing point, where all the parallel lines leading away from
the viewer converge.

The result was a painting that to modern eyes would seem
photographically 'true to life'. The art historian Martin Gayford has
described it as 'the first known picture in history that was intended
not to depict a person, deity, event or object, but to demonstrate
an optical truth'.

The method of viewing Brunelleschi's painting was unusual.
He drilled a small hole in the middle of the panel and the viewer
had to look through the back of the painting to a mirror held up
in front of it. At first you would see the reflection of the painting,
but by moving the mirror away you could see the baptistery itself.
Viewers could then compare the original and the artificial – they
were stunned by the similarity.

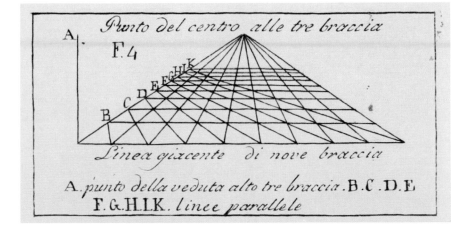

This panel has been lost, as has a similar study Brunelleschi did of the Palazzo della Signoria (now called Palazzo Vecchio) in Florence. But the impact on painting was swift and profound. The convincingly realistic depiction of space that linear perspective allowed caused European painting to make a decisive break from its past, and from most traditions of picture making around the world. Perspective dominated western painting until the twentieth century, when artists began to challenge, subvert or entirely reject this way of seeing the world.

Masaccio
Holy Trinity, 1425–7
Fresco, 6.67 x 3.17 m
(21⅞ x 10⅜ ft)
Santa Maria Novella,
Florence

This is one of the first paintings to show the influence of Brunelleschi's ideas on linear perspective, in the accurately depicted vault above the figures.

KEY ARTISTS
Filippo Brunelleschi (1377–1446), Italy
Masaccio (1401–28), Italy
Leon Battista Alberti (1404–72), Italy

KEY ARTWORK
Masaccio, *Holy Trinity*, 1425–7, Santa Maria Novella, Florence, Italy

CONNECTED EVENTS
1435 – Leon Battista Alberti publishes his book *De pictura*, which contains the first modern account of linear perspective, including guidance for artists to use it in their paintings.
1436 – *Della pittura*, Alberti's translation of the original Latin edition of *De pictura* into the local Italian vernacular, is published.

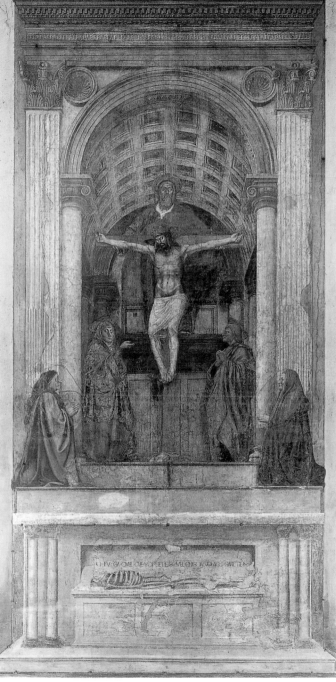

JAN VAN EYCK COMPLETES THE *GHENT ALTARPIECE*
6 MAY 1432, GHENT, BELGIUM

By the mid-1400s, the Italian Renaissance, centred on Florence, was radically and self-consciously transforming what art could achieve. But a new technique discovered in the Low Countries of northern Europe would have an arguably greater impact on the development of painting.

The Italian painters of the time mainly used tempera – a type of paint made with egg yolks – which dried quickly, requiring them to work fast and build up the painting piece by piece. However, Flemish painters such as Jan van Eyck perfected the use of oil paint, which dries more slowly and can be applied in translucent layers. This allowed them to create works of unprecedented detail and depth.

The power of this new technique is demonstrated spectacularly in van Eyck's *Ghent Altarpiece*, a work made from twenty-four painted wooden panels. From the convincingly naturalistic flesh and hair of the naked Adam and Eve to the otherworldly glow of the Lamb of God in the central panel, van Eyck shows his mastery of the new oil paints – indeed, for a long time he was credited with their invention. Like the works of the Italian Renaissance, there is a sense of a new scientific way of looking at the world – note how all the plants and trees depicted can be identified. However, for the artists of the Northern Renaissance, it was based on close observation rather than abstract theories.

An inscription on the outer frame states that the altarpiece was begun by Hubert van Eyck 'than whom none was greater', and it was finished by his brother Jan who completed it in 1432. It was officially installed on 6 May of that year. Little is known of Hubert, and it is now believed he made the frames and set the overall scheme, but Jan did most of the painting after his brother's death.

Jan went on to have a highly successful career. His patron Philip, Duke of Burgundy, paid him handsomely and also sent him on secret international missions. He became a sought-after portrait painter who brought a new focus on the physical individuality of his sitters, as seen in one of his most famous works, *The Arnolfini Portrait*.

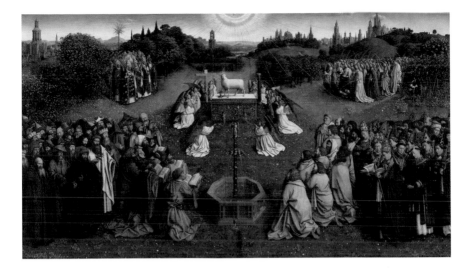

**Above: Hubert and
Jan van Eyck**
*Adoration of the Mystic
Lamb, detail of the Ghent
Altarpiece, c.1423–32*

**The large central panel
shows the Lamb of God
being sacrificed.**

Long considered one of the world's most important artworks, the
altarpiece has had a turbulent history. It had to be guarded against
destruction by iconoclasts (see pages 38–9), parts were taken by
Napoleon's army, by the Germans in both world wars and some
panels were pawned. All were eventually returned except two panels
stolen in 1934 that are still missing.

KEY ARTIST

Jan van Eyck (c.1390–1441), Belgium

KEY ARTWORKS

Hubert and Jan van Eyck, *Ghent Altarpiece*, c.1423–32, St Bavo's
 Cathedral, Ghent, Belgium
Jan van Eyck, *The Arnolfini Portrait*, 1434, National Gallery,
 London, UK

**Overleaf: Hubert and
Jan van Eyck**
*Ghent Altarpiece,
c.1423–32*
Tempera and oil on panel,
open: 350 x 460 cm
(137¾ x 181⅛ in.)
St Bavo's Cathedral,
Ghent

**Hinges allow this
altarpiece to be opened
and closed.**

CONNECTED EVENTS

1942 – At the start of the Second World War, the *Ghent Altarpiece*
 was sent to the Vatican to protect it from the German forces who
 had taken it during the First World War and wanted to reclaim
 it. It only made it as far as France, and in 1942, Hitler ordered
 it to be seized. It was stored first in Neuschwanstein Castle in
 southern Bavaria before being moved to an Austrian salt mine.
 It was restored to Ghent after the war.

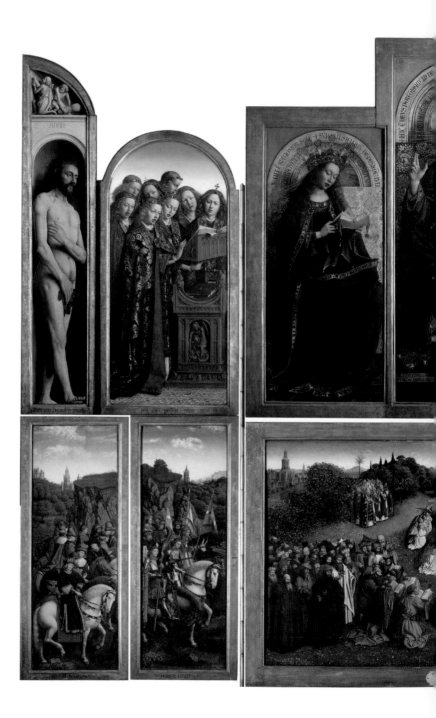

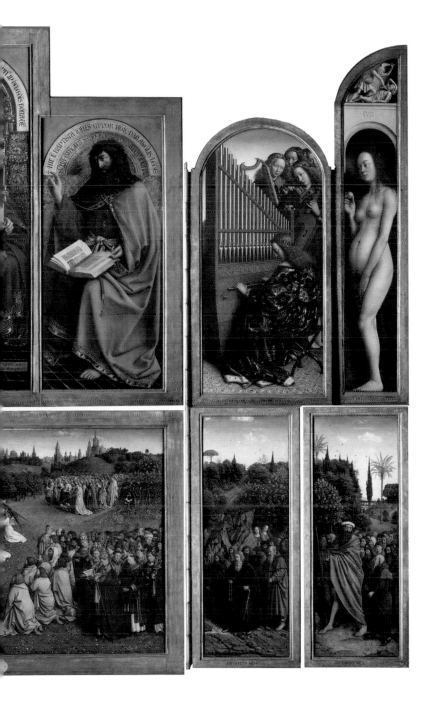

MICHELANGELO UNVEILS HIS MONUMENTAL SCULPTURE OF DAVID
8 SEPTEMBER 1504, FLORENCE, ITALY

Although Michelangelo was just twenty-six years old when he was commissioned to create what has become his most famous work, he was already an accomplished and celebrated artist. He had recently finished his *Pietà*, a statue of the Virgin Mary holding the dead body of Christ. The contemporary writer Giorgio Vasari said it was: 'a miracle that a formless block of stone could ever have been reduced to a perfection that nature is scarcely able to create in the flesh.'

In 1501 Michelangelo had recently returned to Florence, where he had been an apprentice. The authorities in charge of Florence's cathedral were looking for an artist who could finish a statue started decades before and intended to stand on top of the cathedral's north buttress. The extremely large and valuable block of Carrara marble had been badly 'blocked out' by another artist and was lying unfinished in a workshop.

Other artists, including Leonardo da Vinci, were consulted, but Michelangelo convinced them he was the man for the job. It took him over two years of work to turn the block into a giant figure of David. The biblical figure's heroic fight against a larger enemy symbolized the republic of Florence's resistance against the domineering Medici family, and this political significance caused the statue to be pelted with stones several times in its early years.

On 25 January 1504, as the sculpture was nearing completion, the Florentine authorities realized it would be impossible to haul the block of marble weighing over six tons onto the cathedral. A meeting was convened, which included the artists Leonardo and Sandro Botticelli, where it was decided that *David* should stand outside the Palazzo della Signoria, Florence's town hall.

It took four days to move the statue from Michelangelo's studio using an ingenious wooden sling. As the artist was putting the finishing touches to the work, Vasari writes that Piero Soderini, the political leader of Florence, remarked that the nose was too thick. Michelangelo climbed the ladder with his chisel in one hand and

Michelangelo
David (replica), 1501–4
Marble, height 5.17 m
(16⅞ ft)
Palazzo Vecchio, Florence

The original *David* is now in the Galleria dell'Accademia in Florence for safety. This replica stands on its original spot outside the Palazzo Vecchio (then called the Palazzo della Signoria).

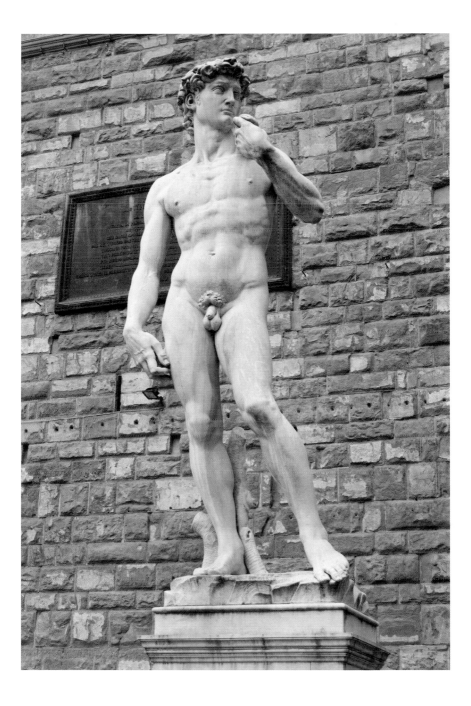

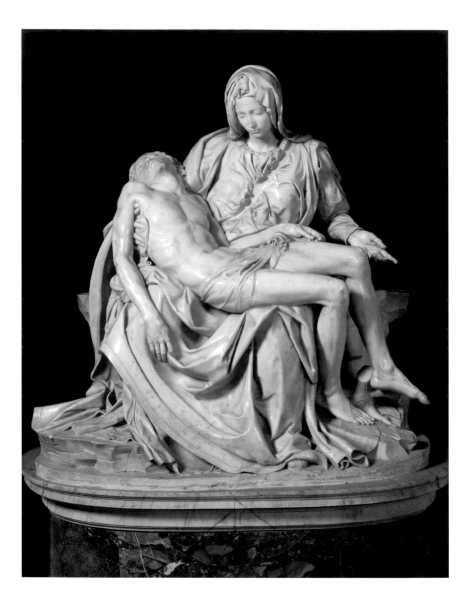

Michelangelo
Pietà, 1498–9
Marble, 174 x 195 cm
(68½ x 76¾ in.)
St Peter's Basilica, Rome

Michelangelo established his reputation with this remarkable sculpture, which he produced in his early twenties.

some marble dust in the other. He pretended to reshape the nose, letting the dust fall to the ground. 'I like it better,' said Soderini, pleased with his intervention, 'You have given it life.'

David confirmed Michelangelo's status as an artistic super talent and the quintessential Renaissance man, in turn solidifying the dominance of Florence and Italy in the sixteenth-century art world. He was later entrusted with many more significant works, including the Sistine Chapel ceiling and the rebuilding of St Peter's Basilica, both in Rome. Other artists found it difficult to emulate the high level of skill behind his sculptures, but his dynamic and emotionally charged paintings led to the development of a new style of art called Mannerism.

KEY ARTIST
Michelangelo (1475–1564), Italy

KEY ARTWORK
Michelangelo, *David*, 1501–4, Galleria dell'Accademia, Florence, Italy, with replicas outside Palazzo Vecchio, Florence, and in collections around the world, including the Victoria and Albert Museum, London, UK

CONNECTED EVENTS
18 February 1564 – Michelangelo dies in Rome while employed as architect of St Peter's Basilica. Although the dome was still incomplete, it was finished to his designs.

12 November 2010 – A fibreglass replica of *David* is installed in its originally intended position on the roof of Florence Cathedral for one day only.

RAPHAEL APPLIES TO PAINT THE POPE'S PRIVATE QUARTERS
MAY 1508, ROME, ITALY

On becoming pope in 1503, Julius II began an ambitious programme of artistic patronage intended to outshine his predecessors and consolidate his power. He demolished the millennium-old St Peter's Basilica in Rome and ordered the construction of the current building. He commissioned Michelangelo to paint the ceiling of the Sistine Chapel's and invited artists from around Italy to paint frescoes on the walls of his private apartments in the Vatican Palace, known as the Stanze (Italian: rooms).

In 1508 Raphael was in his mid twenties. He had grown up in Urbino, where his father was the court painter for the duke. The social graces and connections that this afforded him allowed him to establish himself quickly in first Florence and then Rome. In May 1508 he asked the duke of Urbino for a recommendation: the pope was the duke's uncle.

By 13 January 1509 Raphael was already listed as receiving payment for his work on the Stanze. At first Raphael was just given the Stanza della Segnatura to paint. However, the first fresco he painted, *The Disputation of the Holy Sacrament*, so astounded the pope with its harmonious beauty that he impetuously ordered all the other artists to cease work – only Raphael would be allowed to paint his rooms.

Raphael's rapidly ascending reputation and influence riled Michelangelo, toiling away single-handedly on the Sistine Chapel just metres from Raphael's Stanze. Legend has it that Raphael's friend, the architect Bramante, secretly let him in at night to look at Michelangelo's work in progress. Although Raphael was one of the first artists to respond to the majesty of the ceiling, Michelangelo accused Raphael of plagiarism for years after the latter's death.

The second fresco, *The School of Athens*, is centred on the philosophers Plato and Aristotle, and is considered to be Raphael's masterpiece, with its harmonious but complicated composition of dozens of figures and pioneering vision of classical architecture (inspired, perhaps, by Bramante's plans for St Peter's). However, the later Stanze were painted by Raphael's workshop assistants, working from his drawings. They are usually thought to be of lower quality.

Raphael was extremely influential during his short life (he died at the age of thirty-seven) and afterwards during the seventeenth to nineteenth centuries, when he was considered the epitome of 'an ideal balanced painter', whose works were beautiful, majestic and perfectly made. A backlash started in the mid-nineteenth century, embodied by the English group the Pre-Raphaelite Brotherhood (see pages 82–5). The critic John Ruskin wrote: 'The doom of the arts of Europe went forth from that chamber . . . The perfection of execution and the beauty of feature which were attained in his works, and in those of his great contemporaries, rendered finish of execution and beauty of form the chief objects of all artists; and thenceforward execution was looked for rather than thought, and beauty rather than veracity.'

Raphael
Detail from *The School of Athens*, 1509–11

Raphael featured several of his fellow artists in this fresco: Leonardo da Vinci was the model for Plato (with the long white beard), while the brooding figure in the foreground was based on Raphael's rival Michelangelo.

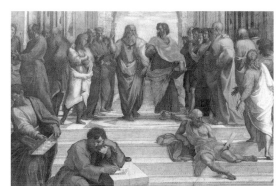

KEY ARTISTS
Raphael (1483–1520), Italy
Donato Bramante (1443/4–1514), Italy
Michelangelo (1475–1564), Italy

KEY ARTWORKS
Raphael, *The School of Athens*, 1509-11, Vatican Museums, Rome, Italy
Michelangelo, Sistine Chapel ceiling, 1508–12, Vatican Museums, Rome, Italy

Overleaf: Raphael
The School of Athens, 1509–11
Fresco, 5 x 7 m
(196⅞ x 275⅞ in.)
Vatican Museums, Rome

CONNECTED EVENT
6 April 1520 – Raphael dies at the age of thirty-seven, allegedly caused by a night of excessive sex with his mistress, Margherita Luti. Known as La Fornarina, she became famous as the archetypal artist's lover/muse.

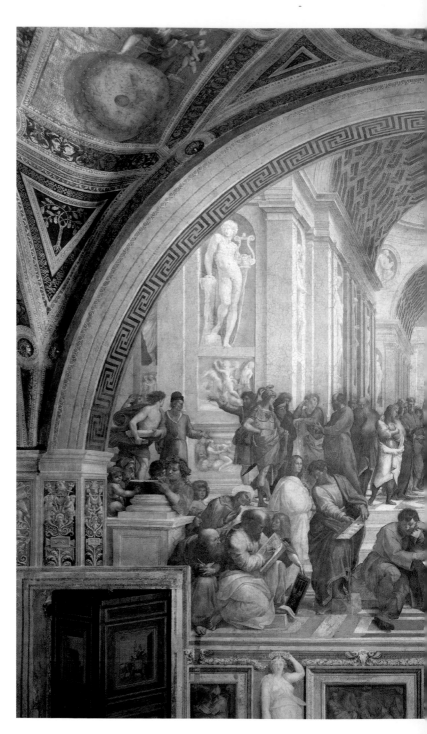

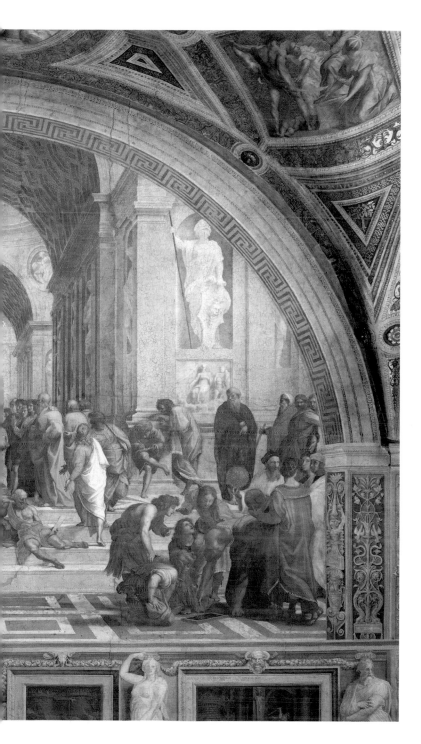

DÜRER PUBLISHES HIS PRINT OF THE RHINOCEROS
1515, NUREMBERG, GERMANY

The live rhinoceros pictured in this print (opposite) was a sensation, the first seen in Europe for over a thousand years. It had been given to the governor of the Portuguese colony in India by a local ruler. The governor sent it back to Lisbon, where it arrived on 20 May 1515.

Europeans were extremely excited by the arrival of this unusual and exotic animal. The rhinoceros had been known only from accounts in the Roman writer Pliny's *Natural History* and it had become legendary, sometimes confused with the unicorn. This living proof of the accuracy of the ancient texts came just as Europeans were rediscovering their classical past. The news swiftly crossed the continent as scholars wrote letters describing its appearance.

Albrecht Dürer, living far away in Nuremberg in present-day Germany, never saw the rhinoceros, but based his drawing on a letter with a sketch by an unknown artist sent to a correspondent in Nuremberg. His woodcut print therefore contains many inaccuracies, including the hide that seems more armour-like than it is in reality and the small extra horn positioned on the neck. The text above describes the rhinoceros as 'fast, impetuous and cunning'.

Dürer was perhaps the most important artist of the Northern Renaissance. He established his reputation as a young man through his mastery of woodcut printing, making use of the recently developed technology of the printing press to spread his work around Europe. *The Rhinoceros* was one of his most popular prints, and remained the archetypal view of the animal until the late 1700s, when another live rhino came to Europe and more accurate paintings were made. The image is still iconic, however, and has influenced many artists, including Salvador Dalí.

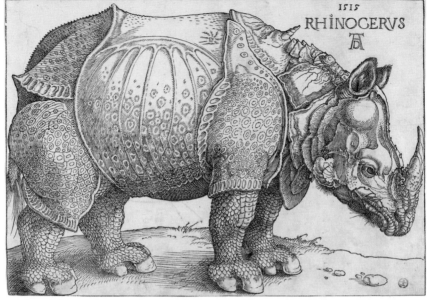

Albrecht Dürer
The Rhinoceros, 1515
Woodcut on paper,
23.5 x 29.8 cm
(9¼ x 11¾ in.)
National Gallery of Art,
Washington, DC

Dürer's woodcut of the
rhinoceros fed a growing
appreciation and interest
in science across Europe.

KEY ARTIST

Albrecht Dürer (1471–1528), Germany

KEY ARTWORKS

Albrecht Dürer, *The Rhinoceros*, 1515, copies of the print are in
many collections, including British Museum, London, UK, and
Metropolitan Museum of Art, New York, NY, USA

CONNECTED EVENTS

c.1439 – Johannes Gutenberg develops the printing press in
Mainz, Germany, starting a new era of books and prints.

26 August 1520 Dürer sees the treasure brought back from
Mexico to the Holy Roman Emperor Charles V, including gold,
silver, armour and weapons. 'I marvelled at the subtle ingenuity
of men in foreign lands,' he writes in his diary.

EMPEROR CHARLES V PICKS UP TITIAN'S BRUSH

1548, AUGSBURG, GERMANY

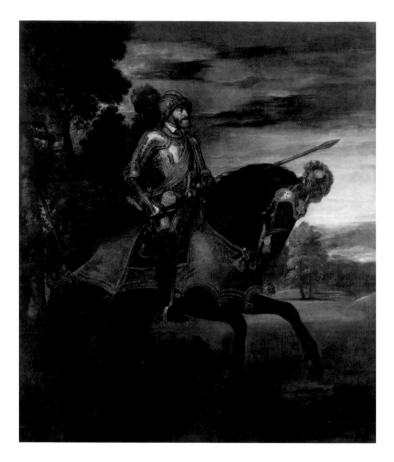

Although a contemporary of Michelangelo and Raphael, Titian was
the most sought-after artist of his time. Titian worked and lived
in Venice, which was then an independent city-state, not subject
to the rule of the pope or any other major power. Although this
removed him from the Renaissance hubs of Florence and Rome,
it gave him a broad client base of wealthy merchants. Venice's status
as Europe's pre-eminent trading city also gave Titian easier access

to the rich colours he is known for: the ultramarine blue he used so unforgettably was ground from precious lapis lazuli imported from Afghanistan via Venice.

During his career Titian had close relationships with some of the most powerful men in Europe, but never let himself become completely beholden to one or the other. He painted portraits for King Philip II of Spain and Portugal. He made a famous painting of Pope Paul III, and he was so friendly with the Holy Roman Emperor Charles V that it made the other courtiers uneasy. It is said that in 1548 when Titian dropped his brush while painting Charles V, the emperor picked it up for him. The painter protested: 'Sire, I am not worthy of such a servant.' To which Charles replied, 'Titian is worthy to be served by Caesar.'

Regardless of the accuracy of this tale – and similar stories that appear in ancient Roman and Chinese writings on art – it reflects a new relationship between artist and patron. No longer nameless craftsmen, artists were now equal in fame to the most powerful kings. Many artists after Titian followed the way he earned his living – working freelance or 'on speculation', following their artistic impulses rather than fulfilling the terms of a commission.

Titian
The Emperor Charles V at Mühlberg, 1548
Oil on canvas,
335 x 283 cm
(132 x 111⅞ in.)
Museo del Prado, Madrid

The Holy Roman Emperor Charles V prized Titian's ability to show him as a strong and successful ruler. This equestrian portrait heavily influenced later depictions of kings on horseback.

KEY ARTIST
Titian (c.1488–1576), Italy

KEY ARTWORKS
Titian, *Pope Paul III*, 1543, Museo di Capodimonte, Naples, Italy
Titian, *The Emperor Charles V of Mühlberg*, 1548, Museo del Prado, Madrid, Spain
Titian, *Philip II in Armour*, 1551, Museo del Prado, Madrid, Spain

CONNECTED EVENT
Fourth century BCE – Apelles of Kos was one the most revered painters of ancient times, although all his works have now been lost. The Roman writer Pliny the Elder recounts that Apelles was once painting a portrait of Alexander the Great, who made some ignorant remarks about art. Apelles asked Alexander to stop talking for fear the apprentice boys would laugh at him; the mighty Alexander apparently took this in good grace because of his respect for Apelles.

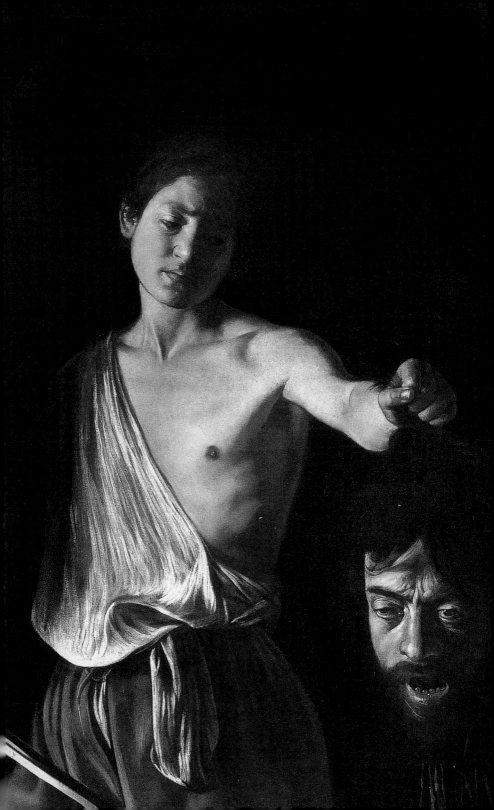

EARLY MODERN

-

**We painters use the same licence
that is permitted to poets and jesters**

-

Paolo Veronese

1573

ICONOCLASTS ATTACK ANTWERP CATHEDRAL
20 AUGUST 1566, ANTWERP, BELGIUM

The riots began on 10 August 1566 in a small town called Steenvorde, now in northern France, but then part of the Seventeen Provinces of the Low Countries. A crowd stormed into a local chapel, smashing the sculptures, slashing the paintings and carrying away anything that could be looted. Over the coming days the attacks spread across the Low Countries, finally reaching the region's richest and most powerful city, Antwerp, on 20 August.

Monasteries, churches, chapels and cathedrals were attacked, reaching a peak in the destruction of the interior of the Cathedral of Our Lady. An English traveller described the scene:

> These fresh followers of this new preaching threw down the graven and defaced the painted images, not only of Our Lady but of all others in the town. They tore the curtains, dashed in pieces the carved work of brass and stone, brake the altars . . . the Blessed Sacrament of the altar they trod under their feet and (horrible it is to say!) shed their stinking piss upon it.

Known in Dutch as the *Beeldenstorm* (statue storm), iconoclastic events of this type had been growing in frequency and scope across northern Europe. The Protestant Reformation, started by Martin Luther in 1517, had gained more supporters in Germany, England and the Low Countries. They disapproved of the rich and beguiling art of Catholic Christianity – exemplified by the art of the Italian Renaissance. Pointing to passages in the Bible that forbade the 'worship of graven images', they resolved to remove, deface and destroy all kinds of images from places of worship. Therefore, while some reports of the *Beeldenstorm* portray a drunken, carnivalesque riot, others portray the statue-breakers as calm, ordered and efficient in carrying out their solemn religious duty.

In England, where a form of Protestantism was the official state religion, iconoclasm was organized by the authorities themselves. In the Low Countries, which were then ruled by the ferociously Catholic Philip II of Spain, revolt against the church was also a rebellion against hated foreign domination, and the *Beeldenstorm* was the beginning of the Netherlands' successful fight for independence.

The many works of art destroyed by the iconoclasts leave an art historical black hole – very little of the religious art from this region survives. The famous *Ghent Altarpiece* (see pages 20–21) had to be hidden in a spire to keep it from destruction by the mobs. In the seventeenth century, Dutch and Flemish art diverged dramatically from that of the south, moving towards non-religious subjects, such as portraits, still lifes, interiors, landscapes and seascapes.

Opposite:
Unknown artist
Altarpiece damaged in the sixteenth century
St Martin's Cathedral, Utrecht

Most religious art – and many buildings – in the Netherlands and Belgium was destroyed during the Protestant Reformation. The heads have been hacked off this altarpiece, which was found behind a false wall in the twentieth century.

Overleaf:
Dirck van Delen
Iconoclasm in a Church, 1630
Oil on panel, 50 x 67 cm (19¾ x 26⅜ in.)
Rijksmuseum, Amsterdam

Painted a generation after the events it depicts, this painting shows iconoclasts tearing down statues from a church. The minimalist, almost empty interiors of the new Protestant churches became a popular subject for painters around this time.

CONNECTED EVENTS

February 1548 – Young King Edward VI orders all images to be removed from English churches, completing the process begun by his father, King Henry VIII.

7 September 1611 – Peter Paul Rubens is commissioned to paint *The Descent from the Cross* as a grand altarpiece for Antwerp Cathedral. Along with his earlier work *The Elevation of the Cross*, it signalled the cathedral's continued allegiance to Catholicism.

VERONESE IS INTERROGATED BY THE INQUISITION
18 JULY 1573, VENICE, ITALY

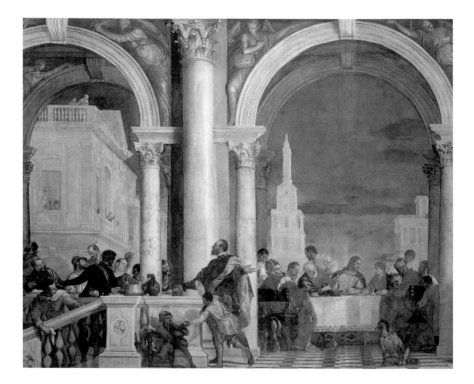

This enormous painting was made for the refectory of a Venetian monastery. It was intended to depict the Last Supper, along the lines of Leonardo da Vinci's famous fresco in Milan. Just as in that work, Christ and his disciples are seated along a long table, parallel to the picture plane. Christ sits at the centre, with St Peter on his right. The uneasy figure in red sitting on the nearside of the table is Judas.

In this painting, however, Paolo Veronese – one the three key Venetian painters of this period, along with Titian and Tintoretto – has added some features that are unfamiliar from the Bible story. Instead of the frugal, plain room shown by Leonardo, Veronese has conjured a spectacular classical palace, the canvas divided up by

three soaring arches. Alongside the disciples, he has painted servers, a dog, dwarves, a jester with a parrot on his wrist and, most bizarrely, a couple of German soldiers.

These unconventional elements attracted the attention of the Inquisition, the Roman Catholic religious police who had recently been granted more powers to stamp down on heresy. Veronese was summoned to explain his actions.

Opposite: Paolo Veronese
Detail from *The Feast in the House of Levi*, 1573

'We painters use the same licence that is permitted to poets and jesters,' he explained.

'Were you commissioned to paint Germans and buffoons and such like figures in this picture?' asked the inquisitor.

'No, my lord: but I was commissioned to ornament the picture as I thought best, which, being large, to my mind requires many figures.'

Veronese was given three months to change the painting – an unusually lenient sentence. Instead, he changed the name of the work to *The Feast in the House of Levi*, after a less important scene in the Bible.

In the following decades, the rise of Protestantism in northern Europe and the subsequent Counter-Reformation in Catholic countries increasingly constrained how artists could approach religious subjects, if at all.

KEY ARTIST

Paolo Veronese (1528–88), Italy

KEY ARTWORK

Overleaf: Paolo Veronese
The Feast in the House of Levi, 1573
Oil on canvas, 5.55 x 12.8 m (218½ x 504 ft)
Gallerie dell'Accademia, Venice

After being challenged by the Inquisition, Veronese changed the title of this work from *The Last Supper*. The new title refers to a scene in the Bible in which Jesus dines with tax collectors and other sinners.

Paolo Veronese, *The Feast in the House of Levi*, 1573, Gallerie dell'Accademia, Venice, Italy

CONNECTED EVENTS

4 December 1563 – The final session of the Council of Trent – a series of conferences to decide key matters of Catholic doctrine in the wake of the Prostantant Reformation – ruled that religious art should be chaste and respectful. 'Nudity' and 'lasciviousness' should be avoided, as should 'unusual images'. As well as Veronese, Michelangelo's work was affected by this ruling. The naked bodies in his *Last Judgement* in the Sistine Chapel were painted over with drapery.

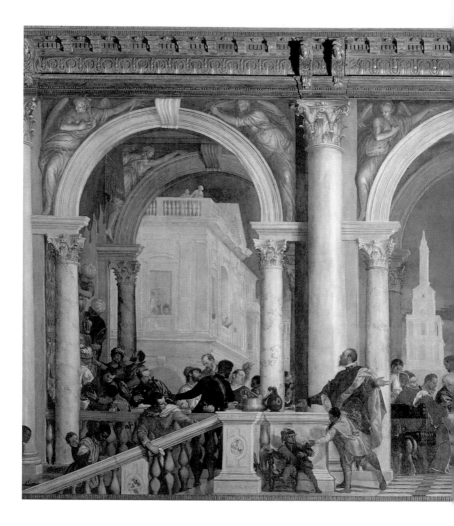

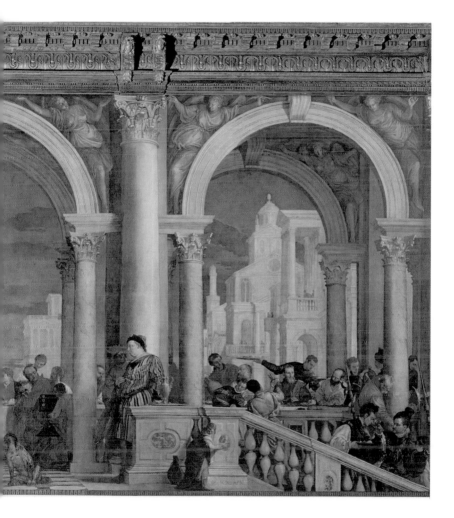

CARAVAGGIO MURDERS A YOUNG MAN
28 MAY 1606, ROME, ITALY

In the early 1600s, the young Caravaggio was the most famous painter in Rome, attracting powerful and influential clients for his radically realistic and dramatic paintings. Caravaggio took the idea of chiaroscuro – using contrasts of light and dark in a painting – to the extreme, using bright shafts of light to pick out his figures against dark backgrounds.

Caravaggio's personality was as dark and dramatic as his art. A contemporary wrote: 'having worked for a fortnight he will then swagger about for a couple of months with his sword at his side and a servant following after, going from one ball game to the next, ever ready to get involved in a fight or argument, so that he is very hard to get along with.'

He regularly got into trouble with the police for brawling in the streets and he carried a pistol without a permit. When his landlady sued him for knocking a hole in the ceiling of his studio, Caravaggio and his friends hurled rocks at her windows. Some have suggested his erratic behaviour was caused by lead poisoning from the paint that he used. Most of the time his important patrons intervened. But on 28 May 1606, Caravaggio killed a young man named Ranuccio Tomassoni in a swordfight. The exact circumstances are unclear but the art historian Andrew Graham-Dixon believes Tomassoni challenged Caravaggio to a duel to avenge an insult. Caravaggio gave his rival a mortal wound just below the crotch and fled Rome with a death warrant hanging over his head.

Being an outlaw did not put a halt to his career. He fled first to Naples, where he painted several major works, before moving on to Malta. Initially received with honour by the religious-military order of the Knights of Malta, before long he had got into another fight, and had to go on the run again. After a failed assassination attempt in 1610, he seemed to be on the verge of receiving a pardon for the

Caravaggio
David with the Head of Goliath, c.1610
Oil on canvas, 125 x 101 cm (49¼ x 39¾ in.)
Galleria Borghese, Rome

Possibly painted the year of his death, in this work Caravaggio has used his own face for the severed head of Goliath. David's compassionate expression has led some to theorize that this painting was Caravaggio's plea for clemency for his crimes.

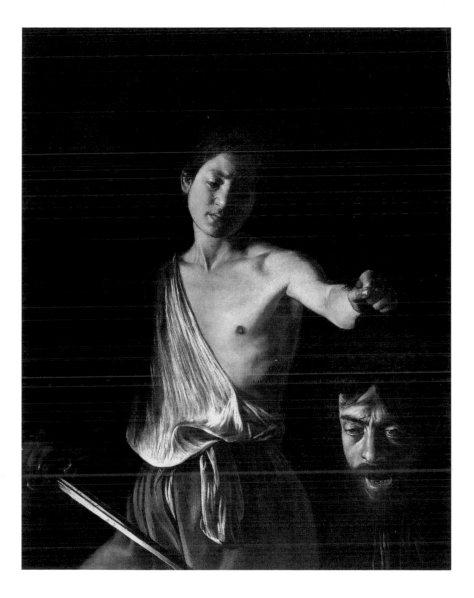

murder and prepared to return to Rome. But he never arrived, dying in mysterious circumstances at the age of thirty-eight.

Although he was extremely famous during his lifetime, the scandal surrounding Caravaggio meant that his rival, Annibale Carracci, had a more direct impact on the next generation of painters. For one thing, Carracci had many students, while Caravaggio was solitary and secretive. However, as later painters discovered his work, his influence spread and a generation of 'Caravaggisti' adopted his characteristic style. Art historian Bernard Berenson wrote: 'With the exception of Michelangelo, no other Italian painter exercised so great an influence.'

Annibale Carracci and Caravaggio
Cerasi Chapel in Santa Maria del Popolo, Rome

Two of Caravaggio's most famous paintings can be seen in this church in Rome, flanking a work painted by his rival, Carracci, in c.1610. Caravaggio's *Crucifixion of St Peter* is on the left and his *Conversion of St Paul* is on the right.

KEY ARTIST

Caravaggio (1571–1610), Italy

KEY ARTWORKS

Caravaggio, *Conversion of St Paul on the Road to Damascus*, 1601, Santa Maria del Popolo, Rome, Italy

Caravaggio, *Crucifixion of St Peter*, 1601, Santa Maria del Popolo, Rome, Italy

Caravaggio, *Seven Acts of Mercy*, 1607, Pio Monte della Misericordia, Naples, Italy

Caravaggio, *Salome Receives the Head of John the Baptist*, c.1609–10, National Gallery, London, UK

Caravaggio, *David with the Head of Goliath*, c.1610, Galleria Borghese, Rome, Italy

CONNECTED EVENTS

1610s – Artemisia Gentileschi becomes the first woman to be accepted into the prestigious Florentine art school the Accademia delle Arti del Disegno. Gentileschi was one of the most successful artists to adopt Caravaggio's style, particularly in her gorily violent paintings of Judith slaying Holofernes, 1614–20.

THE FRENCH ACADEMY IS FOUNDED
20 JANUARY 1648, PARIS, FRANCE

The first art schools were created during the Renaissance in Italy, guiding the training of young painters and sculptors. They operated similarly to medieval guilds, attempting to create a monopoly over the provision of art for the benefit of their members.

The French Académie Royale de Peinture et de Sculpture (Royal Academy of Painting and Sculpture) was founded in 1648. At the time the young King Louis XIV was building his sumptuous palace at Versailles and this academy – as well as others devoted to architecture, music and the decorative crafts – were intended to supply the large quantity of artists and craftsmen required. The academies also had an economic and political purpose: by reducing the reliance on foreign craftspeople and materials, Louis and his advisers hoped to solve France's financial difficulties.

In 1661 the academy came under the control of Jean-Baptiste Colbert, Louis's all-powerful finance minister. He ran it with the first painter to the king, Charles Le Brun, who became director in 1683. This role made Le Brun the dictator of the arts in France, with control over practically every aspect of artistic training, style and production. Considered by Louis XIV to be the 'greatest French painter of all time', Le Brun's lush, classically influenced painting became the standard for French art for almost two hundred years.

Although the impact of academies on art was later considered to be negative, constraining artists' individuality in favour of an official style that became increasingly insipid, the foundation of the academy helped France dominate the international art world in the eighteenth century, and similar institutions sprang up across Europe.

Charles Le Brun
Paintings on the ceiling
of the Hall of Mirrors,
1681–4
Oil on canvas attached
to stucco, length 73 m
(240 ft)
Palace of Versailles,
Versailles

**Le Brun used his power
as the head of the
Académie Royale to take
the most prestigious
projects for himself,
painting key parts of
the Palace of Versailles,
including the vaulted
ceiling of the famous
Hall of Mirrors. Here,
Le Brun painted Louis
XIV's triumphs against
his enemies, amid
gilded stucco and
dazzling mirrors.**

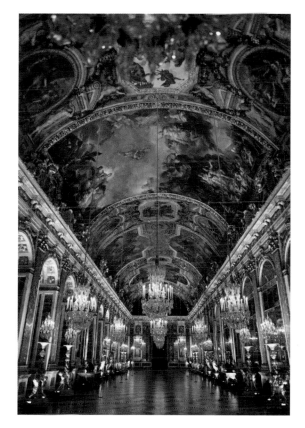

KEY ARTIST
Charles Le Brun (1619–90), France

KEY ARTWORK
Charles Le Brun, ceiling of the Hall of Mirrors at the Palace of
Versailles, 1681–4, Versailles, France

CONNECTED EVENTS
10 December 1768 – The Royal Academy of Arts is founded in
London by artists including Joshua Reynolds and Thomas
Gainsborough, who wanted to give artists in Britain the same
recognition they enjoyed overseas.

8 August 1793 – The Académie Royale is suspended by the
revolutionary National Committee. It later reopens with the
word 'royal' removed from its name. In 1816 it is merged with
several other academies to form the Académie des Beaux-Arts.

REMBRANDT DECLARES BANKRUPTCY
14 JULY 1656, AMSTERDAM, NETHERLANDS

Centuries before Andy Warhol dubbed his studio 'The Factory', artists were operating their workshops as highly commercial endeavours. In the Dutch Golden Age in the mid-seventeenth century, painters such as Rembrandt would have dozens of pupils. As well as being paid money to teach them, the master-painter would be able to sell their work under his own brand name. It is thought that even some of Rembrandt's self-portraits could have been painted partly by his students.

Rembrandt had a complicated relationship with money. Biographical accounts portray him as avaricious – one story says that his pupils regularly glued coins to the floor of the studio to watch him struggle to pick them up. At his peak he would have certainly had a large income: both highly in demand and loath to release a picture before he was happy with it, Rembrandt always had a large queue of people waiting to have their portraits done. He was also an extremely successful engraver: his prints were known throughout Europe.

His spending, however, always kept pace with his income. In 1639 he bought a grand new house in Amsterdam's fashionable Jodenbreestraat area. This building now houses the Rembrandt House Museum. He spent large amounts of money at public auctions, buying old clothes, weapons, armour and other curiosities he would use as stage props in his paintings (he was also generous in lending them out to other painters). Most of all he would spend lavishly on paintings and drawings by other artists, saying he did so to 'emphasize the prestige of his profession'. He has also been accused of buying his own work to bid up the price.

Rembrandt van Rijn
Self-Portrait with Two Circles, c.1665–9
Oil on canvas, 114 x 94 cm (44⅞ x 37 in.)
Kenwood House, London

Many of the works Rembrandt made between his bankruptcy and his death were self-portraits, perhaps reflecting his difficulty in finding models. The circles on the wall might refer to a story about Giotto, who proved his skill as a painter by painting a perfect circle freehand.

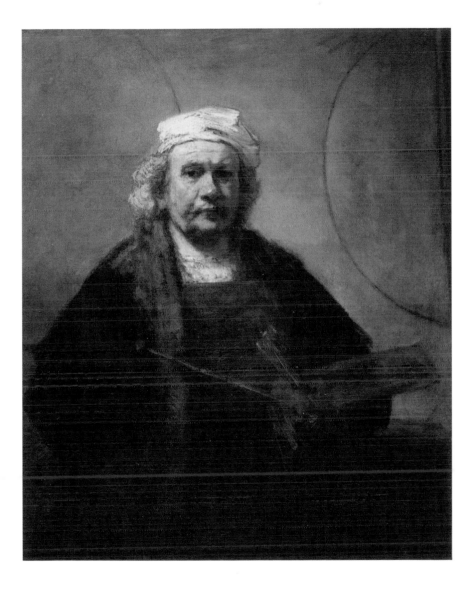

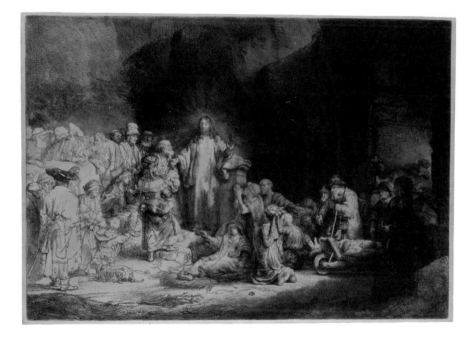

Rembrandt's financial situation got worse after his wife died in 1642, and a servant with whom he had an affair sued him for alimony. On 14 July 1656 he applied for a *cessio bonorum*, a type of bankruptcy in which his assets were turned over to his creditors, many of whom were his friends and associates. Although the collection included rare and exotic objects, such as busts of Roman emperors and suits of Japanese armour, it was not enough to cover his debts and he was forced to sell his house and printing press and move to more modest accommodation. An attempt to put the house in his son's name to avoid it being seized led to the law being changed and Rembrandt's personal reputation ruined.

Rembrandt continued to work until his death, but he was banned from trading as a painter by the city's painters' guild. His new wife and son had to set up a company with Rembrandt as an employee to get around the rule. He died in 1669 and was buried in a pauper's grave – his bones were later taken away and destroyed.

Rembrandt van Rijn
Christ Preaching, c.1648
Print, approx. 28 x 39 cm
(11 x 15⅜ in.)
British Museum, London

At the height of his success, Rembrandt's etchings were prized across Europe. The nickname given to this work, 'The 100 Guilder Print', demonstrates the high prices people would pay.

KEY ARTIST
Rembrandt van Rijn (1606–69), Netherlands

KEY ARTWORKS
Rembrandt van Rijn, *Christ Preaching* ('The 100 Guilder Print'), c.1648, copies in several museums, including the Art Institute of Chicago, Chicago, IL, USA, and the Rijksmuseum, Amsterdam, Netherlands
Rembrandt van Rijn, *Self-Portrait with Two Circles*, c.1665–9, Kenwood House, London, UK

CONNECTED EVENTS
1642 – Rembrandt unveils his most famous painting, *The Night Watch*, an enormous group portrait of the members of Amsterdam's Militia Company of District II. This bustling work, with the life-sized militiamen almost stepping out of the canvas, made Rembrandt's name and epitomizes the thrusting individualism of the young Dutch republic.
12 October 1654 – An enormous explosion at a gunpowder store destroys a large part of the Dutch town of Delft. Among the dozens of dead is the promising painter Carel Fabritius, a pupil of Rembrandt's, along with most of his paintings.

VELÁZQUEZ IS GRANTED A KNIGHTHOOD
27 NOVEMBER 1659, MADRID, SPAIN

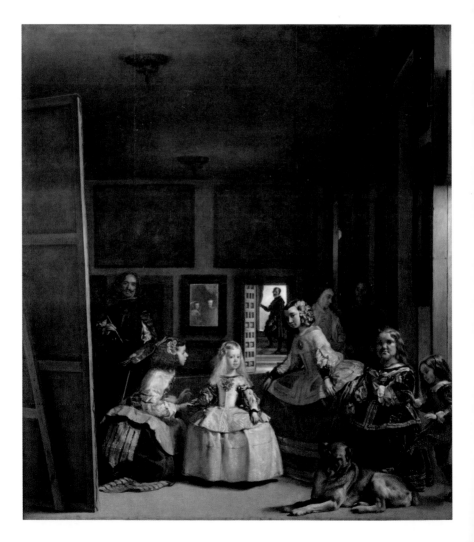

In Diego Velázquez's masterpiece *Las Meninas*, he famously depicts himself, standing before a large canvas, holding one of his characteristically long brushes. Much effort has gone into decoding this complex picture – the mirror at the back of the room seems to show the heads of Velázquez's devoted patron King Philip IV of Spain and his queen. Many think that Velázquez shows himself painting the royal couple, standing in the same position as the viewer, but the actual focus of the painting is the radiant young princess in the centre.

Two signs are more easily decoded. At his waist Velázquez bears the keys of his office. From a humble background, Velázquez made himself a favourite and even confidante of the art-loving king (similar to the close relationship between Titian and Emperor Charles V, page 35). He rose to the high rank of *aposentador mayor*, responsible for the quarters occupied by the court, which left him little time for painting. The second sign was added several years after the painting was completed. On his chest Velázquez bears the red cross of the knightly Order of Santiago. The honour had to be approved by the Council of Orders, which was opposed due to the uncertain status of painters (craftsmen were not allowed) and Velázquez's heritage (a knight's ancestors had to be noble for several generations, whereas some of his grandparents were tradespeople). The council interviewed 148 witnesses over eight months before rejecting Velázquez's claim.

To enable him to knight Velázquez, Philip had to beg the pope for a special dispensation, which was granted on 27 November 1659. Tradition has it that the king himself painted the cross on the chest of his painter, after Velázquez died in 1660; however, Velázquez could have done it himself in the final year of his life.

Diego Velázquez
Las Meninas, 1656
Oil on canvas, 318 x 276 cm (125¼ x 108⅜ in.)
Museo del Prado, Madrid

The title *Las Meninas* refers to the two maids who attend the young princess Infanta Margarita in the centre.

KEY ARTIST
Diego Velázquez (1599–1660), Spain

KEY ARTWORK
Diego Velázquez, *Las Meninas*, 1656, Museo del Prado, Madrid, Spain

CONNECTED EVENT
1814 – British aristocrat William Bankes buys what he believes to be the original *Las Meninas* in Madrid, taking it back to Kingston Lacy, Dorset, southern England. Long thought to be a copy, some scholars now believe it to be Velázquez's original sketch.

'HOGARTH'S ACT' GRANTS ENGRAVERS COPYRIGHT IN THEIR WORK
25 JUNE 1735, LONDON, UK

In the early 1730s, William Hogarth was one of most successful artists in Britain. He started his career as an engraver and had a keen eye for the popular and sensational.

In 1732 Hogarth's recognition reached new levels with the release of *A Harlot's Progress*. Originally created in 1731 as a series of six paintings (now lost) depicting the moral decline of a young country girl, the engraved version became a massive commercial success and Hogarth followed it up with the equally successful *A Rake's Progress*.

Whereas most artists left the engraving of their paintings to a specialist, Hogarth controlled the whole process of engraving, printing, marketing and selling. Few previous artists had been so involved in the commercialization of their work.

However, one factor Hogarth could not control was the unscrupulous print sellers who sold pirated versions of his work, cheating him of his hard-earned and much-desired money. The British Parliament had passed the first modern copyright act in 1710, giving authors control over how their work was reproduced, but it applied only to books. Hogarth and his fellow artists lobbied Parliament and the Engraving Copyright Act, known as Hogarth's Act, was passed in 1735. The first copyright law to deal with visual works, it only protected the creators of engravings – paintings, statues and other artworks were added later.

Hogarth's Act legally recognized that artists owned what they created. The substance of it still regulates the publication of images in many countries around the world today. It is also emblematic of a time when images were becoming more widespread among the general population, rather than primarily for the use of the crown or the church.

William Hogarth
A Harlot's Progress,
1732
Etching and engraving
(plate 2 from a series
of 6), 31.2 x 37.5 cm
(12¼ x 14¾ in.)
National Gallery of Art,
Washington, DC

The series follows a young country girl, Moll, who becomes a prostitute, and dies in the final scene from venereal disease. Here, as mistress to a wealthy Jewish man, Moll creates a diversion while her second lover creeps out of the door.

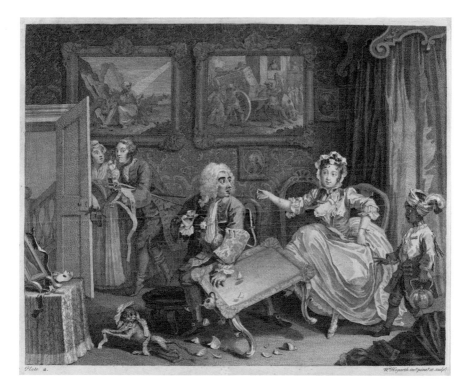

KEY ARTIST
William Hogarth (1697–1764), UK

KEY ARTWORKS
William Hogarth, *A Harlot's Progress*, 1731–2, prints in many
collections, including British Museum, London, UK
William Hogarth, *A Rake's Progress*, 1732–4, original paintings
in Sir John Soane's Museum, London, UK; prints in many
collections worldwide

CONNECTED EVENT
March 1733 – Hogarth visits Sarah Malcolm in Newgate prison as
she awaits execution. Malcolm had been convicted of the brutal
killing and robbery of an elderly widow and her two servants,
which she denied. Hogarth made a painting of her and produced
an engraving which fed the popular interest in Malcolm's crime.
She was hanged a few days later.

DAVID IS COMMISSIONED TO MAKE A PORTRAIT OF THE ASSASSINATED REVOLUTIONARY MARAT
14 JULY 1793, PARIS, FRANCE

The day before the French revolutionary leader Jean-Paul Marat was assassinated in his bath, he was visited by his friend and supporter Jacques-Louis David.

Before the French Revolution, David had established himself as the most prominent painter in the country. His grand history paintings such as *Oath of the Horatii* (1784) marked a return to a more austere and serious style after the frivolously decorative Rococo period of the eighteenth century. A supporter of the revolution from the beginning, after the overthrow of the monarchy, David became a member of the National Convention and voted for the execution of the king. During the short-lived First Republic, David had practically unlimited power over the arts in France and was in charge of organizing public events such as Marat's funeral.

David found Marat in poor health on 12 July. The radical journalist, known as the 'friend of the people', had a debilitating skin condition that he soothed by taking medicinal baths. 'I found him in a state that stunned me,' David later wrote. 'Beside him was a wooden box on which there was an inkwell and paper, and with his hand out of the bath he was writing his final thoughts for the deliverance of the people.'

The next day, Marat was dead – stabbed by a young woman, Charlotte Corday, in his own bathtub. Corday gained access to his house on the pretence of giving an interview, but in reality she held him responsible for the wave of political terror taking hold of France. David shows him slumped, seconds after dying, his pen by his side and a letter from Corday in his other hand. Marat is portrayed as a martyr, and this image was intended to galvanize popular support for the revolution. Despite its coolly considered composition, the painting was made quickly. On the day after the killing, another member of the National Convention asked David 'to return Marat to us whole again'. It was completed by October and copies were

Jacques-Louis David
The Death of Marat, 1793
Oil on canvas, 165 x 128 cm (65 x 50⅜ in.)
Royal Museum of Fine Arts of Belgium, Brussels

Copies of this painting by David's students were widely distributed during the French Revolution. After Robespierre's fall, the original was returned to David, and his family later gave it to the Royal Museum of Fine Arts in Brussels.

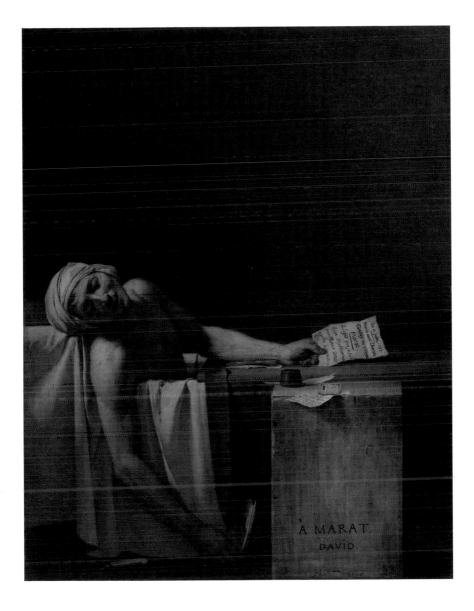

made to be shown around France. David said on presenting the work to the convention:

> Citizens, the people were again calling for their friend; their desolate voice was heard: David, take up your brushes . . ., avenge Marat . . . I heard the voice of the people. I obeyed.

This close association with political events, painting them almost in real time, was a new course for an artist – and a dangerous one. David's closeness to the Jacobin leader Maximilien Robespierre resulted in his imprisonment after Robespierre's fall in 1794. His career was revived under the rule of Napoleon, of whom David made several iconic depictions. But after the restoration of the monarchy in 1815, David fled to Brussels where he lived the rest of his life in self-imposed exile. The painting of Marat also went into hiding and only became famous again once it was displayed in Brussels at the end of the nineteenth century.

Jacques-Louis David
Napoleon Crossing the Alps, 1800
Oil on canvas,
261 x 221 cm
(102¾ x 87 in.)
Château de Malmaison,
Rueil-Malmaison

David continued to serve the new regime of Napoleon, painting propagandistic portraits of the new emperor.

KEY ARTIST
Jacques-Louis David (1748–1825), France

KEY ARTWORKS
Jacques-Louis David, *Oath of the Horatii*, 1784, Musée du Louvre, Paris, France
Jacques-Louis David, *The Death of Marat*, 1793, Royal Museum of Fine Arts of Belgium, Brussels
Jacques-Louis David, *Napoleon Crossing the Alps*, 1800, Château de Malmaison, Rueil-Malmaison, France

CONNECTED EVENT
21 October 1830 – Eugène Delacroix tells his brother about a painting he has started featuring a woman embodying the concept of liberty leading the French people over a barricade. *Liberty Leading the People* becomes an icon of the French republic and commemorates the toppling of King Charles X. Delacroix writes: 'If I haven't fought for my country at least I'll paint for her.'

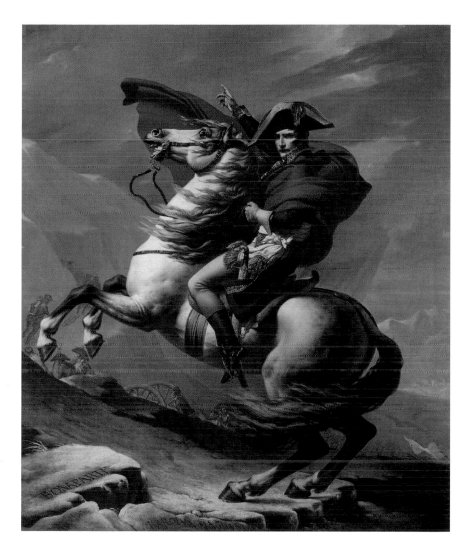

THE LOUVRE OPENS AS A MUSEUM
10 AUGUST 1793, PARIS, FRANCE

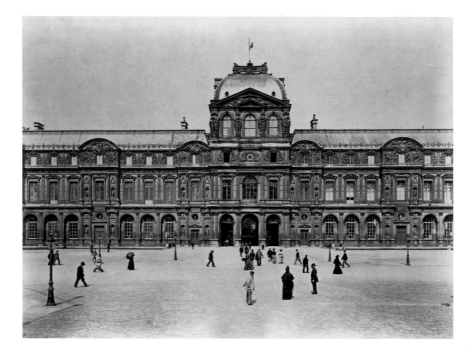

**Exterior of the Musée
du Louvre, Paris**
Photograph, 1890

Built as a fortress and gradually transformed into a sprawling palace, the Louvre was left purposeless when Louis XIV moved his court to Versailles in the late seventeenth century. In the following century, the building was occupied by various societies including the Académie Royale de Peinture et de Sculpture, and some favoured artists were allowed to live at the Louvre. There were also displays from the royal art collection and various proposals were made to turn the Louvre into a permanent museum, similar to the British Museum, which had opened in London in 1759.

The opportunity came when the French Revolution swept the monarchy from power. On 10 August 1792 Louis XVI was arrested and the royal collection in the Louvre – which already included masterpieces such as Leonardo da Vinci's *Mona Lisa* – became public property. A year later the museum opened to the public, a bastion of royalty turned into a democratic resource for everyone.

Unlike many other early museums, which required visitors to apply for entry, the Louvre was open to all. It became a popular source of free entertainment – a scene in Émile Zola's novel *L'Assommoir* of 1877 has its dissolute working-class characters enjoy a trip to the museum, joking around and mocking the artworks.

Hubert Robert
Plan for the Arrangement of the Grand Gallery of the Louvre, 1796
Oil on canvas, 115 x 145 cm (45¼ x 57 in.)
Musée du Louvre, Paris

Robert was part of a committee in charge of the opening the Louvre. He painted many scenes that imagined the future splendour of the museum, and also several showing it in ruins.

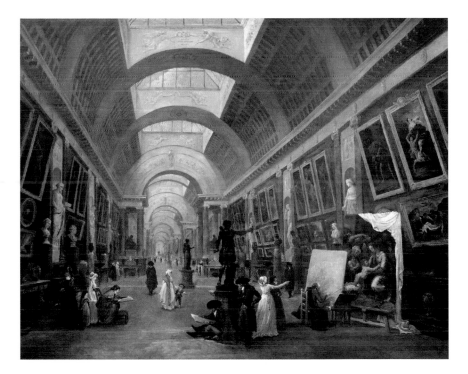

The museum was also an invaluable resource for artists and many of the artists associated with Impressionism including Édouard Manet and Edgar Degas spent lots of time there, learning directly from the Old Masters.

The Louvre's collection grew quickly in its first decades, as France's armies marched across much of Europe. Napoleon decreed that conquered territories – including Italy – send their art treasures to Paris, to be paraded through the streets as booty before being deposited in the Louvre, then renamed the Musée Napoleon. Although many works of art were returned after Napoleon's fall, some remained, including Paolo Veronese's enormous painting *The Wedding at Cana* (1563), which was too big to be shipped back to Venice and was swapped for one by Louis XIV's court artist, Charles Le Brun. Added to progressively ever since, the Louvre is now the world's most visited and best-known art museum.

Unknown sculptor
Apollo Belvedere,
c.120–40 CE
Marble, height
224 cm (88⅛ in.)
Vatican Museums, Rome

This ancient Roman statue was looted by Napoleon's army from Rome and proudly displayed at the Louvre from 1798. It was returned to the Vatican after the fall of Napoleon in 1815.

KEY ARTISTS
Jacques-Louis David (1748–1825), France
Hubert Robert (1733–1808), France

KEY ARTWORKS
Unknown sculptor, *Apollo Belvedere*, c.120–40 CE, Vatican
Museums, Rome, Italy
Leonardo da Vinci, *Mona Lisa*, c.1503–19, Musée du Louvre, Paris,
France

CONNECTED EVENTS
15 January 1759 – The British Museum opens in London, its
collection based on the curiosities collected by Sir Hans Sloane.
15 October 1988 – Work begins on the construction of a new
entrance to the Musée du Louvre, below a glass pyramid
designed by architect I. M. Pei.

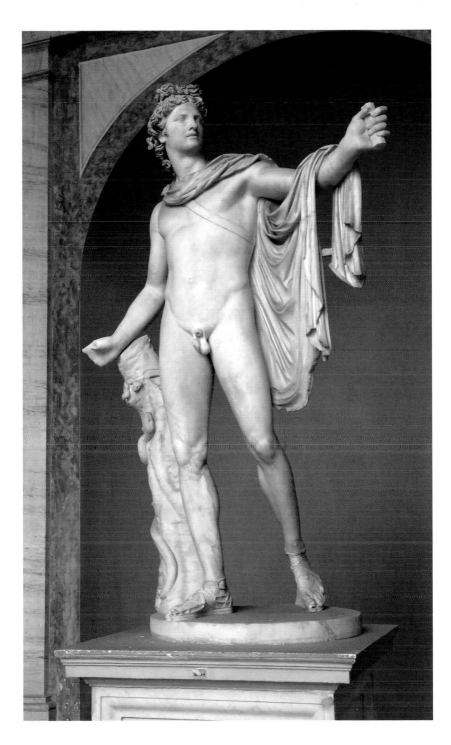

NINETEENTH CENTURY

-

**Painters understand nature and love it,
and teach us to see**

-

Vincent van Gogh

1874

THE PARTHENON MARBLES GO ON SHOW AT THE BRITISH MUSEUM
AUTUMN 1816, LONDON, UK

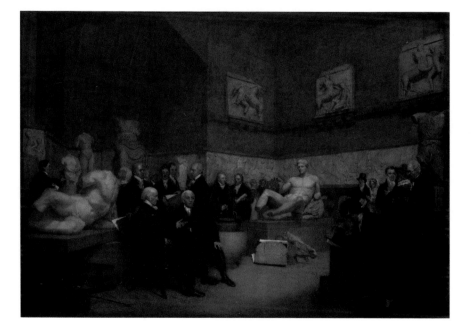

In 1801 Thomas Bruce, 7th Earl of Elgin, obtained permission from the Ottoman Empire which then ruled Athens to take casts and drawings of the marble sculptures that adorned the ancient Parthenon Temple. Dating from the fifth century BCE, they were made at the peak of Athenian civilization and demonstrate a skill in carving and composition not matched for many centuries.

Elgin claimed this permission also allowed him to excavate and remove the sculptures. Soon he started to do so, shipping large quantities of the Parthenon 'marbles' back to Britain, intended to decorate his private home in Scotland. The legality of this removal has long been questioned. An English traveller wrote that there was not a workman involved 'who did not express his concern that such havoc should be deemed necessary'. The issue became one of fierce public debate in Britain, with the poet Lord Byron accusing Elgin of defacing the monuments.

Elgin, needing to recoup some of the £70,000 he had spent on the project, offered to sell the sculptures to the British government. A debate in Parliament in June 1816 exonerated Elgin's actions and the vote was 82–30 to buy the sculptures for the British Museum. Popular opinion became more positive – poets John Keats and William Wordsworth were both inspired by seeing them – and the museum received record crowds.

The Parthenon Marbles arrived in London just as popular interest in antiquity was soaring. They gave a boost to the Neoclassical style that had developed in the preceding decades and many public buildings in London, Edinburgh and elsewhere were built in imitation of ancient Greek and Roman models, including the current building of the British Museum itself, which was begun in 1823.

Archibald Archer
The Temporary Elgin Room in 1819, 1819
Oil on canvas, 94 x 133 cm (37 x 52⅜ in.)
British Museum, London

When the Parthenon Marbles arrived at the British Museum, it was being rebuilt, so they were housed in a temporary room shown here. They are currently displayed in the specially built Duveen Gallery, completed in 1939.

KEY ARTIST
Phidias (fifth century BCE), Greece – the Parthenon Marbles are commonly ascribed to this influential Greek artist.

KEY ARTWORK
Phidias (attributed), Parthenon Marbles, fifth century BCE, British Museum, London, UK

CONNECTED EVENT
February 1506 – The pope sends Michelangelo and other artists to inspect the ancient Roman statue of *Laocoön and His Sons*, unearthed in a vineyard in Rome. The discovery had a profound impact on Renaissance art, including Michelangelo's own works.

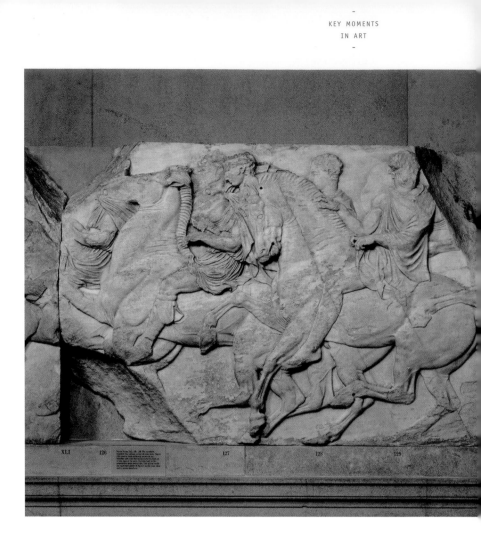

Phidias (attrib.)
Detail from the inner
Ionic frieze, Parthenon
(or Elgin) Marbles, fifth
century BCE
Marble, dimensions
variable
British Museum, London

**About half of the
surviving sculptures
from the Parthenon were
taken to Britain; the
rest are housed in a new
museum in Athens. The
Greek government has
long campaigned for their
return and reunification.**

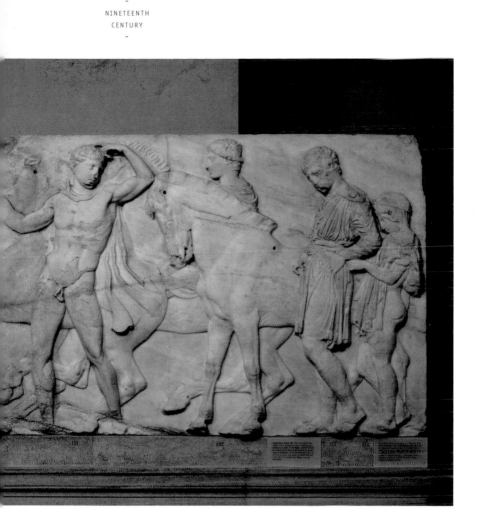

WILLIAM BLAKE SEES THE GHOST OF A FLEA
1819, LONDON, UK

The spirit world was of fashionable interest to Londoners in the early nineteenth century, and the poet and artist William Blake built his reputation on his eccentric, fantastical and grotesque creations.

Blake claimed to have seen visions daily since he was young, which attracted the attention of John Varley, a student of astrology. The two would hold seances in Varley's house, sitting up late into the night. Varley would attempt to summon a historical figure, and Blake would sketch their likeness as if it stood before him.

The Ghost of the Flea – a small but intense painting of a nightmarish half-human monster – is based on one such visitation. Its genesis was described by Varley to Blake's biographer:

> I called upon him one evening and found Blake more than usually excited. He told me he had seen a wonderful thing – the ghost of a flea! 'And did you make a drawing of him?' I inquired.
>
> 'No indeed,' said he, 'I wish I had, but I shall, if he appears again!' He looked earnestly into a corner of the room, and then said, 'Here he is. Reach me my things, I shall keep my eye on him. There he comes! His eager tongue whisking out of his mouth, a cup in his hands to hold blood and covered with a scaly skin of gold and green.' As he described him so he drew him.

The artist told another friend that the 'Flea told him that all fleas were inhabited by the souls of such men who were blood-thirsty to excess.'

Blake was a key figure in the Romantic movement, creating art that was intensely personal and filled with emotion. His work was an inspiration to later visionary British artists, such as Paul Nash and Graham Sutherland, as well as exerting a major influence on popular films, music and graphic novels in the twentieth century.

William Blake
The Ghost of a Flea, c.1819–20
Tempera paint and gold on wood, 21.4 x 16.2 cm (8⅜ x 6⅜ in.)
Tate Britain, London

This painting is very small – on a similar scale to Blake's prints and watercolours – and embellished with gold leaf to heighten the brightness of the highlights.

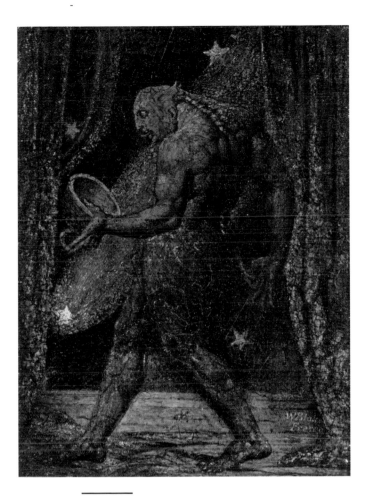

KEY ARTIST

William Blake (1757–1827), UK

KEY ARTWORK

William Blake, *The Ghost of a Flea*, c.1819–20, Tate Britain, London, UK

CONNECTED EVENTS

c.1819–23 – Once the most powerful painter in the Spanish court, by later life Francisco de Goya was isolated and suffered mentally and physically. He rented a humble rural home and painted a series of remarkable and nightmarish visions directly onto its interior walls, known as the *Black Paintings*. Goya never publicized them and they were only discovered after his death.

CONSTABLE WINS A GOLD MEDAL
20 JANUARY 1825, PARIS, FRANCE

In 1824 John Constable was already in his forties but was only just beginning to find success as an artist. Unlike his rival J. M. W. Turner, who was a child prodigy and inducted into the Royal Academy when he was in early twenties, Constable's work struggled to find acclaim in Britain.

Constable and Turner pioneered a new form of Romantic painting. Rather than depicting landscapes as the background to historical or mythological events like the artists of previous generations, or even painting important cities or buildings, Constable focused on the resolutely ordinary views of his native county of Suffolk, in eastern England. He was interested in closely observing and capturing nature – recording the changing clouds, weather and countryside as never before.

In 1819 Constable sold his first major painting and was elected an associate of the Royal Academy. For the next few years, he sent

John Constable
The Hay Wain, 1821
Oil on canvas, 130 x 185 cm (51¼ x 72⅞ in.)
National Gallery, London

The painting depicts Flatford Mill in Suffolk, England, land owned by Constable's father. The cottage depicted still exists to this day.

major paintings to the annual exhibition, which were over two-metres (six-foot) long, including his most famous work, *The Hay Wain*, in 1821. It was seen there by the visiting French Romantic painter Théodore Géricault, who praised it back in Paris. A dealer bought the painting and took it to the 1824 Paris Salon, where it was widely acclaimed and was awarded a Gold Medal by the king.

The French valued Constable much more than his compatriots – despite never leaving Britain, Constable sold many more paintings abroad than he did at home. One of the artists heavily influenced by seeing *The Hay Wain* was Eugène Delacroix, who reworked parts of his masterpiece *The Massacre at Chios* as a result. He was particularly inspired by how Constable varied colour tones in response to lighting conditions and nearby colours.

The influence of Constable's work on French painting was profound. In the decades afterwards, French art took a new interest in the ordinary and everyday, such as in the Realist works of Jean-Baptiste-Camille Corot. Constable and Turner also greatly influenced the Impressionists, including Claude Monet and Camille Pissarro, who viewed their work in London in the 1870s. Like Constable the Impressionists were interested in painting the world as they saw it before them.

Back in Britain, Constable's reputation slowly continued to grow. *The Hay Wain* was voted Britons' second favourite painting in a recent poll – beaten only by Constable's eternal nemesis, Turner.

KEY ARTISTS
John Constable (1776–1837), UK
J. M. W. Turner (1775–1851), UK
Théodore Géricault (1791–1824), France
Eugène Delacroix (1798–1863), France

KEY ARTWORKS
John Constable, *The Hay Wain*, 1821, National Gallery, London, UK
Eugène Delacroix, *The Massacre at Chios*, 1824, Musée du Louvre, Paris, France

CONNECTED EVENT
1832 – J. M. W. Turner upstages Constable at the annual Varnishing Day at the Royal Academy 'Summer Exhibition' in London. Constable's *Opening of Waterloo Bridge* has very subtle colour tones; Turner adds a bright red buoy to his seascape at the last minute in order to draw attention to his own work.

THE INVENTION OF THE DAGUERREOTYPE IS MADE PUBLIC
7 JANUARY 1839, PARIS, FRANCE

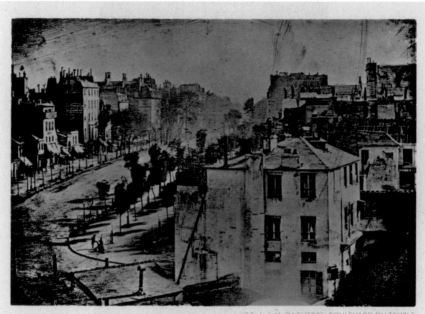

2.2 L. J. M. DAGUERRE: BOULEVARD DU TEMPLE

Photographers were not the first people use a camera to create images. Artists had been using the camera obscura – a device that uses a lens to project an image into a darkened room or box – for centuries. Some art historians believe that well-known artists including Caravaggio and Vermeer secretly used such devices to create their paintings, resulting in the very precise and 'photo-real' look of their work.

As useful as the camera obscura was in guiding artists to draw perspective, it still required them to capture the image in paint or ink. By the early 1830s, an international race was on to

Louis Daguerre
View of Boulevard du Temple, 1838/9
Daguerreotype

This image is the earliest photograph showing people – the boot black and his customer – who stood still enough to be captured in the long exposure.

find a method of fixing the camera's images permanently and automatically.

Louis Daguerre, a French artist and chemist known for the ingenious 'diorama' he ran as a public attraction in Paris, was asked to help Nicéphore Niépce improve his invention, the heliotype. The first successful attempt at chemically fixing a camera image, the heliotype process was nonetheless extremely impractical, requiring exposure times of many hours, even for brightly sunlit scenes.

Daguerre's version was much quicker. Exposure times of mere minutes or seconds meant that making pictures of people was feasible (although still often requiring supports to hold their head and hands still). Instead of making images onto paper, Daguerreotypes are made onto silver-coated copper panels, polished to a perfect mirror shine. Each image is unique and looks different from different angles.

The invention of the Daguerreotype was made public on 7 January 1839 at the Institut de France in Paris. After looking at various ways of commercializing his invention, Daguerre sold the rights to the French government, who gave it as a 'free gift' to the world. This heralded the beginning of the age of photography, as Daguerre's process became popular worldwide, forever changing the way people created and consumed images.

KEY ARTIST
Louis Daguerre (1787–1851), France

KEY ARTWORK
Louis Daguerre, *View of Boulevard du Temple*, 1838/9, original destroyed

CONNECTED EVENT
31 January 1839 – Spurred on by Daguerre's announcement, the Englishman William Henry Fox Talbot reveals his own photographic process, which involves making prints onto paper using negatives. Much cheaper than his rival's and capable of producing multiple prints from a single negative, Talbot's process gained dominance from the 1850s onwards and established the technical basics of photography that lasted until the digital age.

THE PATENT IS ISSUED FOR THE COLLAPSIBLE PAINT TUBE
11 SEPTEMBER 1841, USA

John Goffe Rand was an inventor and a portrait painter. Born in the USA, he moved to England in the 1830s, where he painted aristocrats and members of the royal family.

However, Rand's heavy impact on the history of art came not through his paintings, but through his inventions. Up until that time paint was difficult to make, transport and use. Most paint was sold as powdered pigment that the artists themselves had to laboriously process into a usable paste. This required time and space, and restricted most painters to a studio, usually supported by a team of assistants.

If a painter wanted to work outside – directly in front of a landscape, for example – paint could be transported in heavy and fragile glass jars, or bladders made from animal skin, which would rip and dry up. Rand's invention, which he patented in the USA in 1841, proposed paint could be sold in tubes made from thin, soft metal, such as lead or tin. Squeezing and collapsing the tube would force the paint out, and it could be resealed for transport.

The timing of Rand's invention was perfect. Painters were already becoming more interested in getting out of their studios and painting nature. A wave of inventions in the next few decades made it easier than ever before, including portable easels and canvases pre-primed with white paint. The tube also opened up the range of colours a painter could use, as they did not all need to be mixed individually, and widened access to the bold new colours that had recently been invented by chemists, such as chrome yellow.

The group of French painters known as the Impressionists made enthusiastic use of the new technology, which aided the bright, spontaneous style of painting they championed. The artist Auguste Renoir said: 'Without colours in tubes, there would be no Cézanne, no Monet, no Pissarro, and no Impressionism.'

John Goffe Rand
US Patent 2,252:
Metal Rolls for Paint,
11 September 1841

This shows Rand's original patent for collapsible paint tubes. Aside from a few minor improvements, it is still the system that is used today for paint, toothpaste and similar substances.

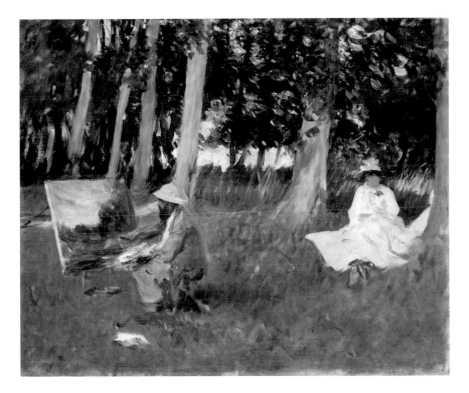

John Singer Sargent
*Claude Monet Painting by
the Edge of a Wood*, 1885
Oil on canvas, 53 x 65 cm
(20⅞ x 25⅝ in.)
Tate Britain, London

Sargent mimics Monet's
characteristic style to
show how the latter artist
worked in the open air,
with a portable easel.

KEY ARTISTS
Claude Monet (1840–1926), France
Camille Pissarro (1830–1903), France
Auguste Renoir (1841–1919), France

KEY ARTWORK
Claude Monet, *Impression, Sunrise*, c.1872, Musée Marmottan
Monet, Paris, France

CONNECTED EVENT
19 February 1990 – The computer program Adobe Photoshop
is released. This image-editing tool and similar programs
allow artists to manipulate photographs as freely as paint.
Artists who have used such digital manipulation in their
work include the German photographer Andreas Gursky and
the British painter David Hockney.

THE PRE-RAPHAELITE BROTHERHOOD IS FORMED
SEPTEMBER 1848, LONDON, UK

In 1849 paintings began appearing across London marked with the mysterious initials 'PRB'. Two were on show at the annual Royal Academy exhibition: one by John Everett Millais and the other by William Holman Hunt. Both painters were precociously talented and young. At the 'Free Exhibition of Modern Art' on Hyde Park Corner the initials could also be seen on a religious painting by the poet and painter Dante Gabriel Rossetti.

These paintings clearly shared a new style and approach. Rossetti's painting looked back to religious art from before the Renaissance, with its stark simplicity. Millais's highly detailed painting shared the jewel-like colours of Jan van Eyck and other early oil paintings. What was afoot?

The meaning of the three letters was unveiled in 1850. They stood for the 'Pre-Raphaelite Brotherhood' and they were the mark of a secret society of painters who had set themselves against the traditional teachings of the Royal Academy. The core of the group was formed one night in September 1848 at 83 Gower Street, the home of Millais's parents in central London. Along with Millais was Hunt, a fellow student at the Royal Academy, and his housemate Rossetti, an aspiring poet. They were all very young – just nineteen years old in the case of Millais and Hunt – and full of rebellious confidence. Later additions swelled their number to seven, and there were many more followers.

The name of the brotherhood was chosen in reaction to the Italian Renaissance painter Raphael, who was judged by the influential art critic, and later supporter of the Pre-Raphaelites, John Ruskin, to have set a low standard for later painters through his idealized view of the world (see page 29). More specifically, the Pre-Raphaelites objected to the constrained teaching of the Royal Academy, which held up Raphael as the ideal model. They mocked the founding director of the academy, Sir Joshua Reynolds, as 'Sir Sploshua'.

John Everett Millais
Isabella, 1849
Oil on canvas, 103 x 143 cm (40½ x 56¼ in.)
Walker Art Gallery, Liverpool

Painted when Millais was only nineteen, this was one of the first paintings to be signed with the initials 'PRB'.

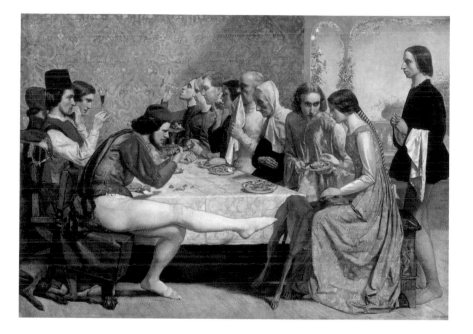

Although the artistic establishment was outraged when the existence of the secret group was revealed – and the Pre-Raphaelites' naturalistic depiction of religious figures including Christ and the Virgin Mary also caused hostility – the innovations of the young artists quickly caught on. Their romantic view of the pre-industrial world was the beginning of the later Arts and Crafts movement led by William Morris.

The Pre-Raphaelites have been described as the first avant-garde art movement. They were one of the first groups to self-consciously come together to pursue a defined and deliberate new programme for art. Although they did not have a written manifesto, they had a short-lived journal, *The Germ*, in which they outlined their ideas and aims. In this they set a template followed by the many artistic movements of the early twentieth century, including the Futurists (see pages 116–9) and the Surrealists.

Dante Gabriel Rossetti
The Girlhood of Mary Virgin, 1848–9
Oil on canvas, 83 x 65 cm (32⅝ x 25⅝ in.)
Tate Britain, London

Rossetti's painting shows the Pre-Raphaelites' interest in medieval Christian themes and iconography.

KEY ARTISTS
John Everett Millais (1829–96), UK
William Holman Hunt (1827–1910), UK
Dante Gabriel Rossetti (1828–82), UK

KEY ARTWORKS
John Everett Millais, *Ophelia*, 1851–2, Tate Britain, London, UK
Dante Gabriel Rossetti, *Ecce Ancilla Domini!* (*The Annunciation*), 1849–50, Tate Britain, London, UK

CONNECTED EVENTS
Summer 1853 – Millais travels to Scotland with the art critic John Ruskin to paint his portrait. While they are there, Millais falls in love with Ruskin's young wife, Effie. The marriage is later annulled and Effie marries Millais.

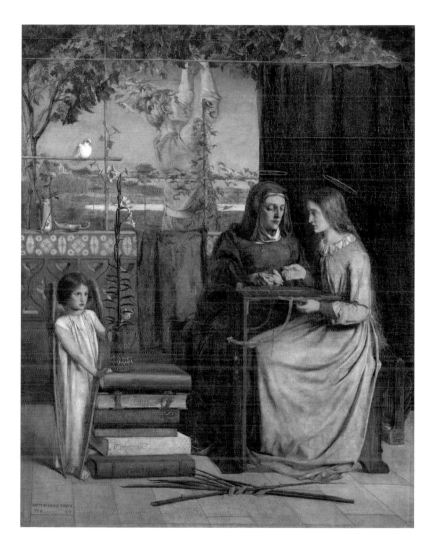

OPENING OF THE SALON
DES REFUSÉS
15 MAY 1863, PARIS, FRANCE

For French artists in the mid-nineteenth century, it was vital to have your works accepted for the annual Salon. Organized by the government through the Académie des Beaux-Arts, the Salon exhibited hundreds of works each year in the Palais de l'Industrie on the Champs-Élysées, selected by a jury. If your work was not picked it was difficult to sustain a career as an artist: the Salon was one of few opportunities to show work to the public and critics, and buyers were unlikely to purchase works that had not received the official sanction of the jury.

This situation became increasingly unsatisfactory. The academy used the Salon to promote its own official style of art – it demanded exquisitely finished paintings in a traditional, Renaissance-inspired style. The new types of painting being created by artists such as Gustave Courbet and Édouard Manet were suppressed.

Things came to a head in 1863, when the jury rejected around two-thirds of the work submitted, including work by artists who had been accepted before. The clamour and complaint reached the emperor, Napoleon III. Although his personal taste in art was conservative, he was keen to be seen as liberal. He proclaimed:

> Numerous complaints have come to the Emperor on the subject of the works of art which were refused by the jury of the Exposition. His Majesty, wishing to let the public judge the legitimacy of these complaints, has decided that the works of art which were refused should be displayed in another part of the Palais de l'Industrie.

The academicians, led by the Comte de Nieuwerkerke, were unhappy about their judgement being questioned. They organized the counter-exhibition as ordered, calling it the Salon des Refusés, but allowed the rejected artists to remove their work if they wished. More than seven hundred, worried about ridicule and cutting themselves off from future commissions, did so.

Of the 1,500 artworks that went on show, many were indeed mediocre. The academy was also careful to hang the worst paintings in the most conspicuous places. Large crowds of up to a thousand people a day came to laugh. However, there were enough works of a clearly distinct and coherent style to convince critics, the public and – crucially – other artists that there was a new movement here.

Perhaps the best-known and most influential painting shown in the Salon des Refusés was Manet's *Déjeuner sur l'herbe*. Provocative and innovative in both technique and subject, showing a naked woman picnicking with two clothed men in a forest, it attracted the

Édouard Manet
Le Déjeuner sur l'herbe, 1863
Oil on canvas, 207 x 265 cm (81½ x 104⅜ in.)
Musée d'Orsay, Paris

Manet's painting caused the biggest scandal of the Salon des Refusés, with its naked woman casually picnicking with two men dressed in modern clothes.

most mockery from the crowds. But it also heralded the beginning of a new modernism in painting and Manet became the de facto leader of the 'independent' artists.

Further Salons des Refusés were held in 1864 and 1873, and some of the excluded artists were included in the regular Salons. However, the academy's conservative policies continued to frustrate the growing band of independents. In 1874 artists, including Edgar Degas, Claude Monet and Berthe Morisot, organized their own display, now considered the first Impressionist exhibition.

James Abbott McNeill Whistler
Symphony in White No.1: The White Girl, 1861–2
Oil on canvas, 213 x 108 cm (83⅞ x 42½ in.)
National Gallery of Art, Washington, DC

Not all the artists at the Salons des Refusés were French. The London-based American artist Whistler submitted this painting of his mistress. It was radical because of its stark simplicity and lack of narrative. Whistler described his work as arrangements of harmonious colours.

KEY ARTISTS

Édouard Manet (1832–83), France
Gustave Courbet (1819–77), France
James Abbott McNeill Whistler (1834–1903), USA

KEY ARTWORKS

Édouard Manet, *Le Déjeuner sur l'herbe*, 1863, Musée d'Orsay, Paris, France
James Abbott McNeill Whistler, *Symphony in White No.1: The White Girl*, 1861–2, National Gallery of Art, Washington, DC, USA

CONNECTED EVENTS

15 April 1874 – Thirty artists display over a hundred and fifty works at the studio of the photographer Nadar in Paris. A critical review mocked it as the 'Exhibition of Impressionists', after Claude Monet's painting *Impression, Sunrise* (c.1872), giving the group its lasting name.

JAPAN SHOWS AT THE EXPOSITION UNIVERSALLE IN PARIS
1 APRIL 1867, PARIS, FRANCE

Since Japan closed its ports to most international trade in the 1640s, little was known of its culture and arts. Tantalizing glimpses were given by the limited amounts of porcelain exported via Dutch traders, the only people the Japanese would do business with, but this was usually tailored to appeal to western taste.

The period of self-imposed seclusion came to an end in 1853, when an American naval delegation arrived and demanded the ports be opened. Aware of China's recent military defeats to another western power, Great Britain, the Japanese rulers acceded.

By 1867 Japan had opened up enough to send a delegation to the Exposition Universelle in Paris. This was the fourth such fair and the biggest yet, with over fifty thousand exhibitors from forty-two countries, attracting around fifteen million visitors. The Japanese national pavilion was a sensation, greatly spreading knowledge and interest in Japanese culture.

A craze began for collecting *ukiyo-e*, the woodblock prints now known best for the examples by Katsushika Hokusai and Utagawa Hiroshige. They started to have a profound effect in France and Britain on young artists, who copied their flat perspective, blocks of unmodulated colour, outlined forms and harmonious but dynamic compositions. Their strong influence can be seen on the works of the French Impressionists and early graphic artists such as Henri de Toulouse-Lautrec. In Britain James Abbott McNeill Whistler absorbed many elements into his *Nocturnes*, while Vincent van Gogh even claimed 'all of my work is founded on Japanese art'.

Utagawa Hiroshige
Sudden Shower over Shin-Ōhashi Bridge and Atake, from the series *One Hundred Famous Views of Edo*, 1857
Woodblock print,
36.3 x 24.1 cm
(14⅜ x 9½ in.)
Library of Congress, Washington, DC

***Ukiyo-e* woodblock prints like this famous example by Hiroshige were popular from the seventeenth century with the middle class in Japan, who used them to decorate their homes.**

Although the influence of 'Japonism' did not last long, it was the first time that western artists had begun to look seriously at other image-making traditions and absorbing their lessons. At the beginning of the twentieth century, a similar craze for African arts influenced the work of artists including Amedeo Modigliani and Pablo Picasso. The rules and methods of painting that had dominated the west since the Renaissance were beginning to be questioned and their intellectual, technical and aesthetic superiority were no longer assured.

Vincent van Gogh
*Bridge in the Rain
(after Hiroshige)*, 1887
Oil on canvas, 73 x 54 cm
(28¾ x 21¼ in.)
Van Gogh Museum,
Amsterdam

Japanese *ukiyo-e* prints were very influential on Vincent van Gogh, who collected hundreds of them and even painted this copy of one by Hiroshige.

KEY ARTISTS

Katsushika Hokusai (1760–1849), Japan
Utagawa Hiroshige (1797–1858), Japan
Vincent van Gogh (1853–90), Netherlands
James Abbott McNeill Whistler (1834–1903), USA

KEY ARTWORKS

Katsushika Hokusai, *The Great Wave*, from the series *The Thirty-Six Views of Mount Fuji*, c.1830–2, woodblock prints in collections worldwide, including Metropolitan Museum, New York, NY, USA and the Bibliothèque Nationale de France, Paris, France
Utagawa Hiroshige, the series *The Fifty-Three Stations of the Tōkaidō*, 1833–4, woodblock prints in collections worldwide, including Brooklyn Museum, New York, USA, and Ashmolean Museum, Oxford, UK
James Abbott McNeill Whistler, *Nocturne: Blue and Gold – Old Battersea Bridge*, c.1872–5, Tate Britain, London, UK

CONNECTED EVENTS

May or June 1907 – Pablo Picasso sees African art in the ethnographic museum at the Palais du Trocadéro in Paris. He experiences a revelation and introduces two figures inspired by African masks into his seminal painting *Les Demoiselles d'Avignon* (1907; see pages 112–13).

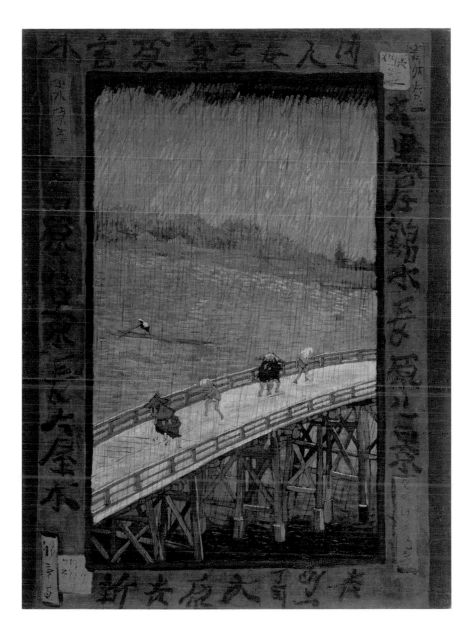

RODIN DEFENDS HIMSELF
2 FEBRUARY 1877, BRUSSELS, BELGIUM

Auguste Rodin is now perhaps the best-known sculptor in the world after Michelangelo. However, the start to his artistic career was unsteady. Rejected from the École des Beaux Arts several times, he spent his twenties doing odd jobs and struggling with poverty.

In his mid-thirties, Rodin scraped together enough money to visit Italy. His encounters with the work of Donatello and Michelangelo were revelatory and validated his desire to break free of the constraints of the academic sculpture then in vogue.

On his return, Rodin set to work on *The Age of Bronze*. A life-size sculpture of a naked man, this work drew on his experience of seeing Michelangelo's artwork in Florence. It is strikingly realistic rather than in the idealized style then dominant, and its dynamic twisting posture means it can be appreciated from all angles. The model was a young Belgian soldier called Auguste Ney. The left arm originally carried a spear but Rodin later removed it to free the sculpture of any association with war.

In January 1877 the plaster model of *The Age of Bronze* was shown in the Cercle Artistique in Brussels where it caused a scandal. The sculpture was so skilfully done, with such unprecedented realism, that Rodin was accused in a newspaper review of casting it from the model rather than making it himself – in short, critics said he had cheated. The life-size dimensions of the work supported this argument.

Rodin wrote an angry letter to the newspaper on 2 February: 'If any connoisseur would do me the favour of reassuring himself on this point, I will show him the model and he can judge how far an artistic interpretation must be removed from a slavish copy.'

Auguste Rodin
The Age of Bronze, modelled 1875–6
Bronze, 104.1 x 35 x 27.9 cm (41 x 13¾ x 11 in.)
National Gallery of Art, Washington, DC

Thirty years after completing *The Age of Bronze*, **Rodin claimed that he'd conceived of it as 'an awakening . . . from a deep dream'.**

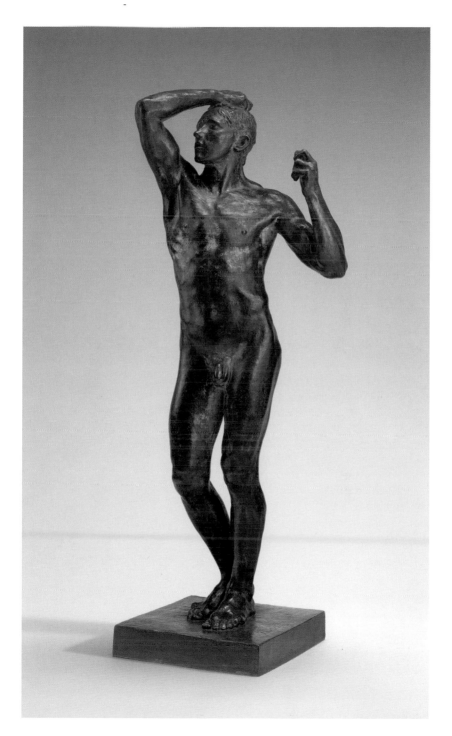

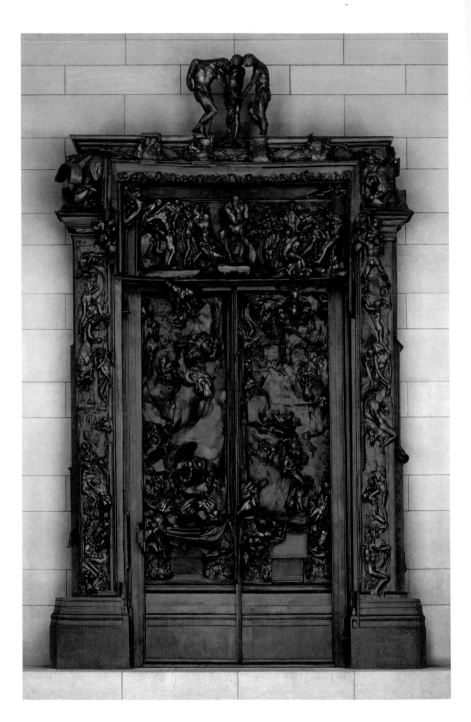

Auguste Rodin
The Gates of Hell,
modelled 1880–1917,
cast 1926–8
6.37 x 4.01 x 0.85 m
(20⅞ ft x 13⅛ ft
x 33⅜ in.)
Rodin Museum,
Philadelphia

Rodin's masterpiece
***The Gates of Hell* includes**
smaller versions of many
of his most famous
sculptures, including
***The Thinker*, visible in the**
centre above the doors.

This accusation dogged Rodin when he submitted the work to the Paris Salon later that year (still, despite its name, the plaster version, as casting in bronze was expensive). Although it was accepted, the controversy led to it being displayed in a poor position. Mortified and angry, Rodin had to call in the support of his fellow artists, who testified to his skill in improvising from memory, his energy and extraordinary ability in modelling. This evidence was ignored and he found himself unable to sell the work, resigning him to three years of poverty until a friendly government minister finally persuaded the state to purchase the work and have it cast in bronze.

Despite the embarrassment, the scandal helped to make Rodin's name. Although his career continued to be dogged with bad luck, Rodin went on to create some of the world's most famous sculptures, including *The Kiss* (1901–4) and *The Thinker* (1903), and his work marks the starting point of modern sculpture

KEY ARTIST

Auguste Rodin (1840–1917), France

KEY ARTWORKS

Auguste Rodin, *The Age of Bronze*, 1877–80, casts in several museums, including Musée d'Orsay and Musée Rodin, Paris, France; Rodin Museum, Philadelphia, PA, USA; and Victoria and Albert Museum, London, UK
Auguste Rodin, *The Gates of Hell*, 1880–c.1890, casts in several museums, with the original in Musée d'Orsay, Paris, France

CONNECTED EVENTS

1880 – Rodin wins the commission to design an entrance to a planned Decorative Arts Museum in Paris. Expected to be delivered in 1885, Rodin worked on the *The Gates of Hell* for the rest of his life, taking inspiration from Dante Alighieri's epic poem *Divine Comedy* (the museum was never built anyway).

CÉZANNE'S FATHER DIES
23 OCTOBER 1886,
AIX-EN-PROVENCE, FRANCE

While there is truth in the cliché of the struggling artist starving in a Parisian garret – Pablo Picasso, for instance, lived in abject poverty in his early years – it does not apply to Paul Cézanne. His father was the founder of a successful bank and throughout his life, Paul was financially secure.

In many ways this easy money caused more problems than it solved. Cézanne senior did not approve of his son's chosen career, and Paul was forever anxious of alienating him and having his monthly allowance of 100 francs cut off. When Paul had a son with his mistress, Marie-Hortense Fiquet, he kept it a secret from his father, who indeed threatened to disinherit him when he found out.

Despite the personal drama it caused, Cézanne's financial security freed him as an artist. While his contemporaries were constrained by the necessity of selling pictures and winning commissions, Cézanne was able to pursue his own creative impulses, no matter how uncommercial they were. It also allowed Cézanne to distance himself from the Parisian art scene. In 1880 his father had a studio built for him in the eaves of the family home, Le Jas de Bouffan, a grand country estate in Aix-en-Provence in the south of France. In 1886 his father died, leaving the estate to Paul.

Aix was a respectable provincial town completely removed from the radical air of Montmartre, the Parisian artists' quarter. There was no art scene and the locals at times were displeased to have a controversial artist in their midst. But Aix provided both an array of interesting landscapes to paint – from his house he could see Mont Sainte-Victoire, which became the subject of his celebrated series of paintings – and gave Cézanne the time and the peace to concentrate on pushing the boundaries of painting.

The style Cézanne created in Aix laid the foundations for modern art, directly influencing the likes of Henri Matisse and Pablo Picasso, who called him 'the father of us all'. Instead of painting the world

Paul Cézanne
La Montagne Sainte-Victoire, c.1887
Oil on canvas, 65 x 95 cm
(25⅝ x 37⅜ in.)
Musée d'Orsay, Paris

From the house he inherited from his father, Cézanne could see Mont Sainte-Victoire, which he painted again and again.

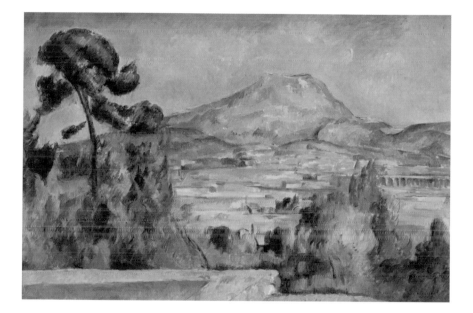

from a single stable viewpoint, Cézanne attempted to capture the experience of the roving eye, showing objects from slightly different perspectives simultaneously. He would take 100 sessions to paint a still life, painting and repainting his subject so the outlines were uncertain yet everything fitted together like a jigsaw.

Towards the end of his life, Cézanne was becoming well known and young artists travelled to Aix-en-Provence to learn from him. A large retrospective of his work in Paris at the Salon d'Automne in September 1907 (see pages 112 and 114) had a major impact on avant-garde artists, including Pablo Picasso, Georges Braque and Jean Metzinger, the latter of whom wrote in 1912:

Paul Cézanne
Still Life with Milk Jug and Fruit, c.1900
Oil on canvas, 45.8 x 54.9 cm (18⅛ x 21⅝ in.)
National Gallery of Art, Washington, DC

Cézanne once claimed he wanted to 'astonish Paris with an apple', which he achieved with his vivid still lifes.

> Cézanne is one of the greatest of those who changed the course of art history . . . His work proves without doubt that painting is not . . . the art of imitating an object by lines and colours, but of giving plastic form to our nature.

KEY ARTIST
Paul Cézanne (1839–1906), France

KEY ARTWORKS
Paul Cézanne, *La Montagne Sainte-Victoire with Large Pine*, c.1890, Courtauld Gallery, London, UK
Paul Cézanne, *Still Life with Onions*, 1896–8, Musée d'Orsay, Paris, France

CONNECTED EVENT
December 1885 – Cézanne's childhood friend Émile Zola publishes the first part of his novel *L'Oeuvre* (The Masterpiece). The main character is an eccentric and unsuccessful painter, partly based on Cézanne, who breaks off his friendship with Zola.

MONET BUYS HIS HOUSE IN GIVERNY
NOVEMBER 1890, GIVERNY, FRANCE

Like Paul Cézanne, the Impressionist painter Claude Monet spent the latter part of his career living and working in his own home in the French countryside. Unlike Cézanne (see page 98), Monet bought his house using his own means, thanks to his increasing success and fame as an artist.

After looking at several other villages and suburbs around Paris, Monet finally settled on Giverny in northern France, spotting it from a passing train. In 1883 he rented a large, two-storey country house with two acres of land. Monet needed the space because he had started a relationship with the woman who was to become his second wife, Alice Hoschedé, who had six children of her own, as well as his two sons. The house was close to the local schools and there was a barn he could use as a studio.

Claude Monet
Bridge over a Pond of Water Lilies, 1899
Oil on canvas,
92.7 x 74 cm (36½ x 29 in.)
Metropolitan Museum of Art, New York

Monet began by painting the Japanese bridge that crossed his pond, before focusing in on the waterlilies floating on its surface.

Monet's work became increasingly popular, and by November 1890 he was prosperous enough to purchase the house and land. Monet began to intensively redevelop the house and gardens throughout the 1890s, employing seven gardeners to whom he wrote daily instructions. In 1893 he bought more land and commenced a vast landscaping project, turning a water meadow into the waterlily ponds that would appear again and again in his paintings for the rest of his life.

Monet's first paintings of his house and gardens were fairly conventional Impressionist fare, akin to his earlier paintings of cities, rivers and fields. The works of the late 1890s broke new ground: instead of finding interesting landscapes to paint, Monet was creating the landscapes himself. Towards the end of his life, probably exacerbated by his failing eyesight caused by cataracts, he focused ever more tightly on the waterlilies in his pond, creating immense paintings in which nothing is left but water, lilies and reflections. Although still depicting the real world, these works are almost abstract and set a precedent for twentieth-century modern art.

Monet's house
Modern photograph

Monet's house and gardens in Giverny, northern France, are now open as a tourist attraction.

KEY ARTIST
Claude Monet (1840–1926), France

KEY ARTWORKS
Claude Monet, *Water Lilies*, over 200 paintings; the most famous on permanent display at Musée de l'Orangerie, Paris, France

CONNECTED EVENT
9 May 1904 – Thirty-six of Monet's paintings of London go on show in Paris. The views were made on several trips to London between 1899 and 1901, where he revelled in the lighting effects created by the fog and poor weather.

GAUGUIN LEAVES FOR TAHITI
4 APRIL 1891, PARIS, FRANCE

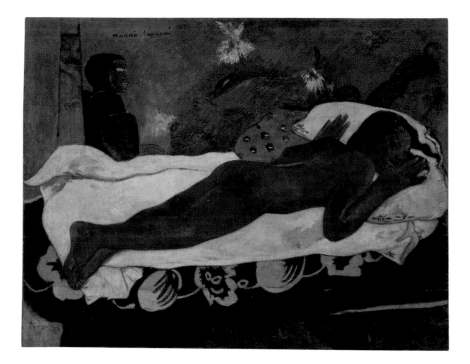

After a grand farewell dinner at the fashionable Parisian nightspot the Café Voltaire, at which his friends and fellow artists drank toasts and made speeches, Paul Gauguin boarded a night train and set off on his two-month journey to the other side of the world: he was bound for Tahiti, the tiny island in the middle of the Pacific Ocean that had been colonized by France.

Gauguin had led an itinerant life. He had a privileged early upbringing in Peru; his family was forced to return to France when he was six because of the changing political situation but he had life-long reminiscences of his 'tropical paradise'. In later life he spent time in Copenhagen with his Danish wife, and in 1887 visited Central America, where he lived in an indigenous hut and painted the exotic landscape and people.

Back in Paris, Gauguin's reputation as a painter was growing steadily, but he was not achieving the commercial or critical success he felt he deserved. He was friendly with many of the Impressionists, particularly Edgar Degas, and exhibited his paintings at the eighth 'Impressionist Exhibition' in 1886. However, his work was growing apart from theirs. Rather than capturing the sensations of the eye, Gauguin's work turned towards the products of the mind. His paintings became more personal and symbolic, his colours bolder and less naturalistic.

In 1891 he became convinced that he needed to get away from Europe and its influences. 'Even Madagascar is too near the civilized world,' he wrote to a friend. 'I shall go to Tahiti and I hope to end my days there. [My art] is only a seedling so far and out there I hope to cultivate it for my own pleasure in its primitive and savage state.' To raise money for the passage, Gauguin's friends held an auction of his work, at which many of them bought generously, some perhaps guiltily as they had promised to accompany him.

Gauguin arrived in Papeete, the Tahitian capital, in June 1891 to find a disappointing shanty town rather than the exotic idyll he had imagined. After three months he moved to a more remote part of the island, where he lived in a wooden hut and took a thirteen-year-old local girl as a lover and wife. He later wrote a book, *Noa Noa*, which presents a romanticized account of this time, focusing on his encounter with the exotic sensuality of life on Tahiti and glossing over what has later been seen as his sexual and cultural exploitation of the Tahitians.

These few years were extremely productive as he absorbed Tahitian culture and mythology. His portraits of his young wife and other locals are notable for their careful portrayal of non-western facial features – then extremely novel. He sent works back to Paris,

Paul Gauguin
Manaò tupapaú (Spirit of the Dead Watching), 1892
Oil on jute, mounted on canvas, 73 x 92.4 cm
(28¾ x 36⅜ in.)
Albright-Knox Art Gallery, Buffalo

This painting depicts Gauguin's thirteen-year-old Tahitian wife, Teha'amana. She lies vulnerable, afraid of the ghost that sits behind her.

where they were well received but by now he was running out of
money and relied on the French government to pay for his return
to Paris in August 1893.

Back in Europe, Gauguin was moderately successful and played
up his exotic reputation by dressing in Polynesian clothes and
taking a 'Javanese' mistress. However, he soon quarrelled with his
friends, split permanently from his Danish wife and was injured
in a bar-room brawl. Disillusioned and depressed, he set off for
the Pacific again in June 1895, and died eight years later on the
Marquesas Islands.

A posthumous show of his work in 1906 solidified his reputation,
and was a major influence on the young Pablo Picasso, who was then
working on his early masterpiece Les Demoiselles d'Avignon (1907;
page 113). Along with Vincent van Gogh and Paul Cézanne, Gauguin
was a key Post-Impressionist who created the foundation for
modern art. His interest in non-western civilizations was taken up
by the next generation who moved decisively away from European
painting traditions.

Paul Gauguin
*Vahine no te tiare (Woman
with a Flower)*, 1891
Oil on canvas, 70 x
46 cm (27½ x 18⅛ in.)
Ny Carlsberg Glyptotek,
Copenhagen

**This is the first work
Gauguin sent back
from Tahiti. In his
travel journal *Noa Noa*,
Gauguin explains that
she is a neighbour he
persuaded to sit for
a portrait 'in order
to familiarize myself
with the distinctive
characteristics of the
Tahitian face'.**

KEY ARTIST
Paul Gauguin (1848–1903), France

KEY ARTWORKS
Paul Gauguin, *Vahine no te tiare (Woman with a Flower)*, 1891,
 Ny Carlsberg Glyptotek, Copenhagen, Denmark
Paul Gauguin, *Manaò tupapaú (Spirit of the Dead Watching)*,
 1892, Albright-Knox Art Gallery, Buffalo, NY, USA

CONNECTED EVENT
23 December 1888 – Vincent van Gogh cuts off part of his ear
 after quarrelling with Gauguin, who had been persuaded to join
 the Dutch artist in Arles in southern France.

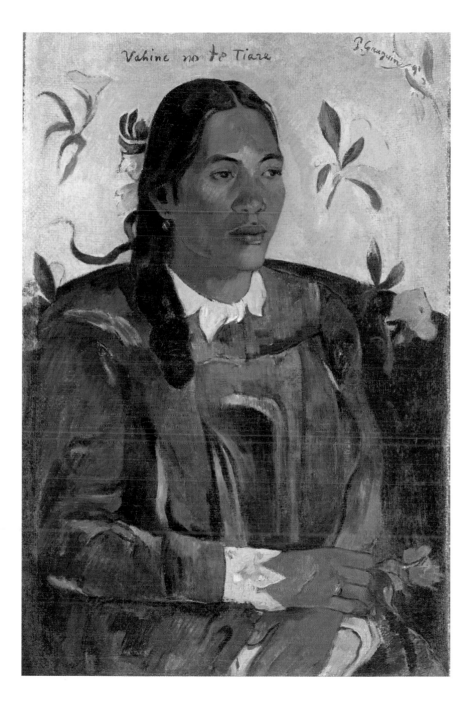

THE VIENNA SECESSION IS FOUNDED

3 APRIL 1897, VIENNA, AUSTRIA

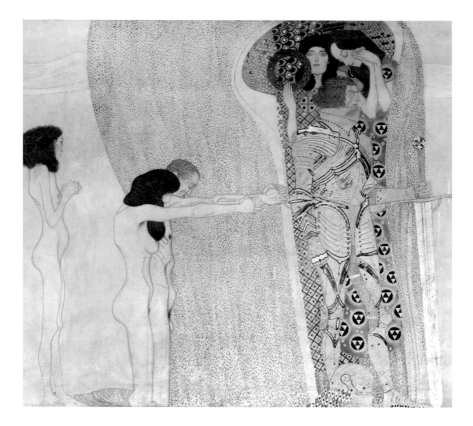

Vienna at the turn of the twentieth century was awash with artistic
and intellectual innovation, home to the psychoanalyst Sigmund
Freud and the composer Gustav Mahler, among many others.
But for contemporary artists, there was only one place to show
their work, the Künstlerhaus run by the Austrian Artists' Society.
This institution was reluctant to support new developments in art,
from home or abroad, in part because they received a ten per cent
commission and traditional works sold better.

Gustav Klimt
Detail from the *Beethoven Frieze*, 1901–2
Gold, graphite and paint on wall, approx. 2.15 x 34 m (7 x 111⅞ ft)
Secession Building, Vienna

Klimt painted this frieze, intended to be temporary, for the fourteenth Vienna Secessionist exhibition, which honoured the composer Ludwig van Beethoven.

Frustrated by the society's policies, a group of painters, sculptors and architects led by Gustav Klimt resigned and started their own group, the Vienna Secession. Influenced by the Arts and Crafts movement in Britain and Art Nouveau, the Secession artists were committed to the idea of the *Gesamtkunstwerk* (German: total artwork), which would combine art, decoration and architecture into a completely designed artistic environment.

As such the most important statement of their movement was the Secession Building that served as their exhibition space. Constructed in 1898 in a prime site donated by the supportive government, and designed by the architect Joseph Maria Olbrich, the building combines classical influences with a modern simplicity, adorned with decorations inspired by nature, including a dome of golden leaves.

The Secession was formed in a great outpouring of energy, with regular exhibitions and a twice monthly publication of their journal, *Ver Sacrum*, and quickly gained attention around Europe. However, its heyday was short-lived, with the group splintering in June 1905 with the resignation of Klimt and his supporters. (In the following years, Klimt made his most famous works, including *The Kiss*.) Despite this setback – and the impact of the two world wars, during which the Nazis burned down the Secession Building – the group still exists to this day and holds shows in the rebuilt exhibition building.

KEY ARTIST
Gustav Klimt (1862–1918), Austria

KEY ARTWORKS
Gustav Klimt, *Beethoven Frieze*, 1901–2, Secession Building, Vienna, Austria
Gustav Klimt, *The Kiss*, 1907–8, Belvedere Museum, Vienna, Austria

CONNECTED EVENT
4 April 1892 – The Munich Secession is formed, an earlier breakaway group in another German-speaking city with similar aims and ambitions to the Vienna Secession.

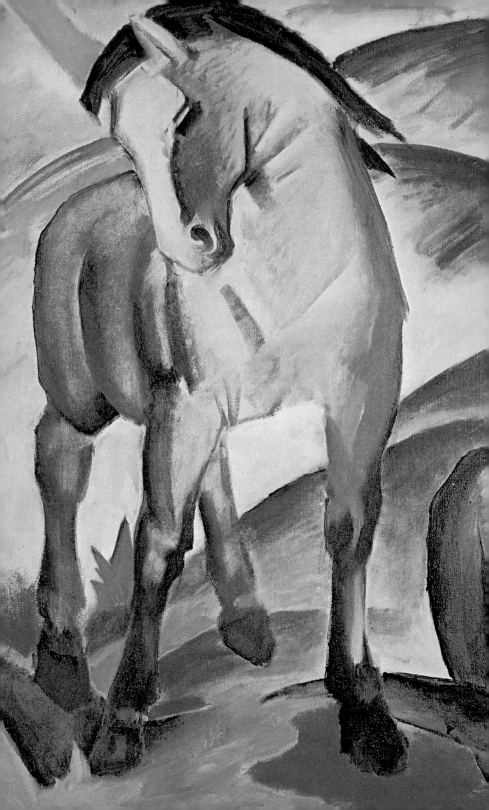

EARLY TWENTIETH CENTURY

-

Colour is a means of exercising direct influence
upon the soul. Colour is the keyboard; the eye is
a hammer; while the soul is a piano of many strings.
The artist is the hand [which] causes the
human soul to vibrate

-

Wassily Kandinsky

1911

THE TERM 'CUBISM' IS COINED
14 NOVEMBER 1908, PARIS, FRANCE

Several names for artistic movements were originally intended as insults, including 'Impressionists' and 'Fauves'. The art critic Louis Vauxcelles, who gave the latter name to the 'wild' paintings of Henri Matisse and André Derain, also popularized the term 'Cubism'.

In November 1908 a show of works by the painter Georges Braque opened at the gallery of Daniel-Henry Kahnweiler. These paintings had been rejected from the annual Salon d'Automne – due, Braque suspected, to the influence of his former teacher Matisse, who was furious that Braque now worked closely with his rival Pablo Picasso.

One of the key paintings in the show was *Houses at l'Estaque* (1908). Braque, like Picasso and many other avant-garde artists then living in Paris, had been heavily influenced by a major retrospective of Paul Cézanne's work that was held at the previous Salon d'Automne. *Houses at l'Estaque* was one of several paintings by Braque to experiment with Cézanne's deconstruction of perspective. It also shows the impact of his deepening relationship with Picasso and particularly the influence of the latter's ground-breaking work *Les Demoiselles d'Avignon* (1907), which had not yet been shown in public but had shocked and surprised the fellow artists who had viewed it in Picasso's squalid studio.

According to Vauxcelles, it was a jealous Matisse who came up with the term, drawing him a sketch to show how Braque's picture was constructed out of 'little cubes'. Vauxcelles adopted the phrase, writing in his review of the Kahnweiler show that Braque was a daring artist who 'reduc[es] everything, places and figures and houses, to geometric schemas, to cubes'.

Vauxcelles continued to use the term derogatively, referring to artists including Jean Metzinger and Robert Delaunay in 1910 as 'ignorant geometers, reducing the human body . . . to pallid cubes'.

Pablo Picasso
Les Demoiselles d'Avignon, 1907
Oil on canvas, 244 x 234 cm (96 x 92⅛ in.)
Museum of Modern Art (MoMA), New York

Fellow artists, including Braque, were unsure what to make of Picasso's radical painting. While others mocked it, Braque studied its innovations closely.

By the time of the 1911 Salon d'Automne, even the front page of the *New York Times* was proclaiming: 'The "Cubists" dominate Paris's fall salon.'

Despite being the two artists most identified with the style, Picasso and Braque disliked the phrase but were eventually obliged to use it. The work they made together in the following years is almost indistinguishable. Their paintings are shattered into numerous forms and angles, with the subject – a woman, a fruit dish, a violin – only barely perceptible. Instead of trying to represent a single visual experience, which painters had tried to do since the Renaissance, they attempted to paint multiple viewpoints simultaneously.

Braque said about his partnership with Picasso:

The things that Picasso and I said to one another during those years will never be said again, and even if they were, no one would understand them anymore. It was like being roped together on a mountain.

This intense creative relationship was brought to an end by the beginning of the First World War. But the movement they had created went on to transform what we think of as art, leading to many of the later artistic developments of the twentieth century.

Georges Braque
Houses and Tree, 1908
Oil on canvas, 40.5 x
32.5 cm (16 x 12¾ in.)
Lille Métropole
Museum of Modern,
Contemporary and
Outsider Art (LaM), Lille

This painting was made as a response to the works of Paul Cézanne, who had also spent time at L'Estaque, a village near Marseille in the south of France.

KEY ARTISTS
Pablo Picasso (1881–1973), Spain
Georges Braque (1882–1963), France

KEY ARTWORKS
Pablo Picasso, *Les Demoiselles d'Avignon*, 1907, Museum of
Modern Art (MoMA), New York, NY, USA
Georges Braque, *Houses at l'Estaque*, 1908, Lille Métropole
Museum of Modern, Contemporary and Outsider Art, Lille, France

CONNECTED EVENT
31 October 1903 – The first Salon d'Automne opens at the Petit
Palais in Paris, a reaction to the continued conservatism of the
official Paris Salon. The first show includes a retrospective of
the recently deceased Paul Gauguin, as well as work by Francis
Picabia, Pierre Bonnard and Henri Matisse. Over the following
years it becomes established as the main showcase for avant-
garde art.

THE FUTURIST MANIFESTO IS PUBLISHED ON THE FRONT PAGE OF *LE FIGARO*

20 FEBRUARY 1909, PARIS, FRANCE

One winter Saturday in 1909, the readers of the French newspaper *Le Figaro* awoke to find an outrageous and extravagant artistic declaration on the front page.

Written by the Italian poet Filippo Tommaso Marinetti, the tract was so wild that the newspaper's editors felt it necessary to introduce it with a caveat: 'Mr Marinetti . . . has just founded the school of "Futurism", whose theories surpass in daring all those expounded by other schools . . . Need we add that we ascribe to the signatory all responsibility for his unusually bold ideas . . .?'

The Futurist manifesto was a deliberate provocation, a challenge to artists and writers to come to terms with a rapidly modernizing world. It followed the form of political manifestoes such as Karl Marx and Friedrich Engels's *Communist Manifesto* (1848) in its high-flying rhetoric and denunciation of the established order. It rejected the reverence shown to the past (especially in Marinetti's native Italy) and instead celebrated speed, technology, energy and vitality.

'We affirm that the world's magnificence has been enriched by a new beauty: the beauty of speed,' runs a key passage, claiming that a racing car is more beautiful than the classical statues in the Louvre. The manifesto vows to destroy 'museums, libraries and academies of any kind' and glorifies 'the love of danger, the habit of energy and fearlessness'. It first appeared in Italian as a preface to a volume of Marinetti's poems in January 1909, and then in a local Italian newspaper, before being translated into French and published in *Le Figaro*. Marinetti read it out on stage, gave lectures in London, Moscow, St Petersburg and Berlin and threw printed copies out of taxis. This was a well-planned and effective communications strategy that made the most of modern media.

Marinetti's manifesto
Le Figaro, 20 February 1909
Newspaper article

Marinetti's manifesto appeared in the local Italian newspaper *Gazzetta dell'Emilia*, before appearing in the French national newspaper *Le Figaro*.

55e année — 3e Série — N° 51 Le Numéro avec le Supplément = SEINE & SEINE-ET-OISE : 15 centimes — DÉPARTEMENTS : 20 centimes Samedi 20 Février 1909

Gaston CALMETTE
Directeur-Gérant

RÉDACTION — ADMINISTRATION
26, rue Drouot, Paris (9e Arr.)

POUR LA PUBLICITÉ
S'ADRESSER, 26, RUE DROUOT

LE FIGARO

H. DE VILLEMESSANT
Fondateur

RÉDACTION — ADMINISTRATION
26, rue Drouot, Paris (9e Arr.)

Le Futurisme

M. Marinetti, le jeune poète italien et
français, au talent remarquable et fougueux,
que de retentissantes manifestations ont
fait connaître dans tous les pays latins,
vient d'un groupe d'enthousiastes disciples,
vient de fonder l'École du « Futurisme ». Les
théories déposées se hardiront toutes sur
la valeur de leurs esthétiques et leurs
morales. Le Figaro qui a déjà servi de tri-
bune à plusieurs d'entre elles, et non des
moindres, offre aujourd'hui à ses lecteurs le
manifeste des « Futuristes ». Est-il besoin de
dire que nous laissons à son auteur toute la
responsabilité de ses idées singulièrement au-
dacieuses et d'une outrance souvent injuste
pour des choses éminemment respectables ? Mais
c'est intéressant de réserver à nos lecteurs
la primeur de cette manifestation, quel que
soit le jugement qu'on porte sur elle.

Manifeste du Futurisme

1. Nous voulons chanter l'amour du
danger, l'habitude de l'énergie et de la
témérité.

2. Les éléments essentiels de notre
poésie seront le courage, l'audace et la
révolte.

[The remaining body text of the Futurist Manifesto and the columns below is not clearly legible at this resolution.]

LA VIE DE PARIS

« Le Roi » à l'Élysée... Palace

Échos

La Température

Les Courses

À Travers Paris

Nouvelles à la Main

Le complot Caillaux

Source gallica.bnf.fr / Bibliothèque Nationale de France

Umberto Boccioni
Unique Forms of
Continuity in Space, 1913
Bronze, 121.3 x 88.9 x
40 cm (43¾ x 35 x
15¾ in.)
Metropolitan Museum
of Art, New York

**Boccioni's sculpture
depicts a figure contorted
by speed and explores
the Futurist notion of
the mechanized body.**

The original manifesto provided no positive guidance on what Futurist art might look like, but dozens more manifestoes followed over the next few years, and the Futurist cause was taken up by painters, sculptors, architects and writers alike across Europe. Other new artistic movements, such as Cubism, were swept up in the intellectual tumult, and it is sometimes difficult to differentiate strictly Futurist works from other contemporary art movements, such as Cubism and Constructivism.

As a result, although Futurism was spectacularly influential, kicking off a wave of self-consciously avant-garde art movements and in many ways marking the beginning of Modernism itself, there are very few great Futurist works of art. The First World War drained the movement of much of its energy and in the 1920s, the Futurists' love of violence (the original manifesto described war as 'the world's only hygiene') led many of them, including Marinetti, towards Fascism.

KEY ARTISTS

Umberto Boccioni (1882–1916), Italy

KEY ARTWORKS

Umberto Boccioni, *Unique Forms of Continuity in Space*, 1913, original plaster cast in Museu de Arte Contemporânea, São Paulo; other casts in museums in New York, London, Milan and elsewhere

Giacomo Balla, *Abstract Speed + Sound*, 1913–14, Peggy Guggenheim Collection, Venice, Italy

CONNECTED EVENTS

2 July 1914 – The first issue of *BLAST* magazine is published in London. Mainly written by the English artist Wyndham Lewis, it was an attempt to seize back control of the avant-garde from Marinetti and founded the short-lived Vorticist group.

23 July 1918 – Poet Tristan Tzara reads his Dada manifesto at a party in Zurich. The movement aimed to supplant the Futurists and had the same love of writing manifestos; however, it was anti-war and focused on the silly and satirical.

MONA LISA IS STOLEN FROM THE LOUVRE
21 AUGUST 1911, PARIS, FRANCE

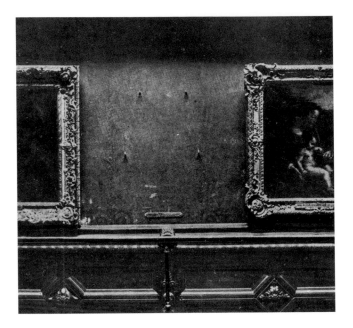

When a painter arrived at the Louvre one Tuesday morning in 1911 to sketch the *Mona Lisa*, he found only four hooks on a bare wall. He asked the guard where the missing Leonardo da Vinci portrait was but no one was particularly concerned – the Louvre's photographers often took paintings down to their studio. The truth was it had been stolen the morning before.

When news of the theft became known, two young men in the artist's quarter of Montmartre panicked. Pablo Picasso had two ancient statuettes in his cupboard that had been stolen from the Louvre by his friend, the poet Guillaume Apollinaire, who had once called for the Louvre to be burned down. They were both arrested on 7 September, but Picasso denied everything in court and the case against them broke down.

Blank wall at the Louvre
Press photograph, 1911

It is likely the thief picked the *Mona Lisa* partly because of its small size – just 77 cm (30⅓ in.) high – which meant that it could be hidden under his clothes.

In fact the *Mona Lisa* had been stolen by an Italian immigrant called Vincenzo Peruggia. He had worked at the Louvre and had even made the painting's glass frame. Hiding in a cupboard over night, he then simply lifted the painting off the wall, removed the frame and escaped with it hidden under his overalls. The painting spent two years on his kitchen table before he was caught trying to sell it in Italy. Peruggia seems to have been motivated by national pride, under the false impression that the *Mona Lisa* was one of the paintings looted from Italy by Napoleon (see page 65).

The *Mona Lisa* was already much loved, but the publicity around the theft made it truly iconic as its image was reprinted millions of times in newspapers, which had recently started to regularly print photographs. It was perhaps the first artwork to pass into popular culture and the start of the era of mass reproductions of paintings.

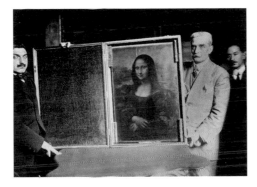

Recovered *Mona Lisa*
Press photograph, 1913

The *Mona Lisa* was missing for over two years and was only recovered when the thief tried to sell it to a museum in Florence.

KEY ARTIST
Leonardo da Vinci (1452–1519), Italy

KEY ARTWORK
Leonardo da Vinci, *Mona Lisa*, c.1503–19, Musée du Louvre, Paris, France

CONNECTED EVENTS
1919 – Artist Marcel Duchamp turns a cheap postcard of the *Mona Lisa* into a 'readymade' artwork by drawing a moustache on it.
12 February 1994 – One of the four versions of *The Scream* by Edvard Munch is stolen from the National Museum in Oslo, Norway. Police recover it undamaged in May 1994. Another version was stolen in 2004 and recovered in 2006.

'DER BLAUE REITER' EXHIBITION OPENS
18 DECEMBER 1911, MUNICH, GERMANY

In the years leading up to the First World War, new artistic groupings sprang up on a seemingly monthly basis across Europe, each championing new and different artistic styles and theories. The dominance of the formal training academies was over and the art of the future was up for grabs.

One of the most influential groups was formed in Munich, Germany, owing to a disagreement among the members of the Neue Künstlervereinigung München, itself only a few years old. The Russian-born artist Wassily Kandinsky, who had been president of the previous group, decided it was too strict and traditional, and set up a new group with artists including the German-born Franz Marc.

The name Der Blaue Reiter (German: The Blue Rider) is of uncertain origin but seems to refer to the two leading artists' love of riding and a belief in the spiritual nature of the colour blue. The movement lacked a formal manifesto but the artists shared a desire to express spiritual truths through their art. They were interested in the symbolic and expressive qualities of colour, which they used in a vivid and unnaturalistic manner. Their subject matter became dreamlike and abstract, and Kandinsky in particular moved away from representation altogether, as he tried to capture the characteristics and feelings of music in paintings he termed 'improvisations' or 'compositions'. The works he made around this time are some of the earliest abstract paintings ever made.

Although Der Blaue Reiter was short-lived as a group, splitting up as a result of the First World War, in which Marc was killed, it was remarkably influential. An exhibition, which opened on 18 December 1911 in Munich, featured forty-three works by fourteen artists, including the French painters Robert Delaunay and Henri Rousseau as well as Kandinsky and Marc. The exhibition toured Europe up until July 1914, visiting cities including Cologne, Berlin, Budapest, Oslo and Helsinki.

Wassily Kandinsky and Franz Marc
Cover of *Der Blaue Reiter Almanach*, 1911
Printed paper, 30 × 22 cm (11¾ × 8⅞ in.)
Private collection

Der Blaue Reiter Almanach spread the ideas of the group, including articles on art theory by Kandinsky and examples of art by artists belonging to the group or those they admired.

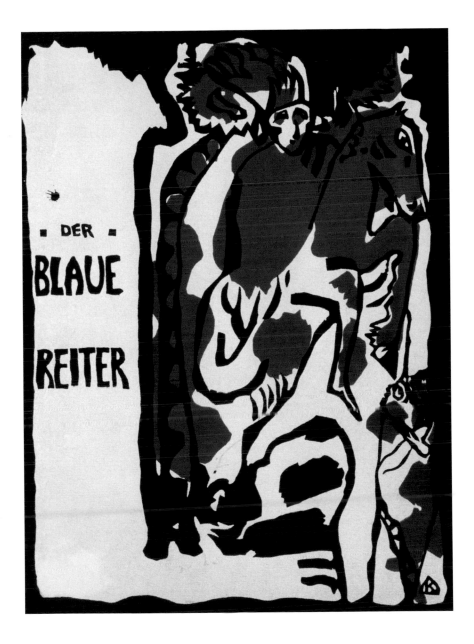

Along with the earlier Dresden-based movement Die Brücke (German: The Bridge), the work of Der Blaue Reiter artists is considered to be part of German Expressionism. Kandinsky was able to further promote and spread his ideas in between the wars as a teacher at the Bauhaus art school, before it was closed by the Nazis and Kandinsky's work was branded degenerate (see pages 134–5).

Franz Marc
Blue Horse I, 1911
Oil on canvas
112 x 86 cm (44⅛ x 33⅞ in.)
Lenbachhaus, Munich

Franz Marc often painted dreamlike pictures of blue horses, which contributed to the name of the group Der Blaue Reiter (The Blue Rider).

KEY ARTISTS

Wassily Kandinsky (1866–1944), Russia
Franz Marc (1880–1916), Germany

KEY ARTWORKS

Franz Marc, *Blue Horse I*, 1911, Lenbachhaus, Munich, Germany
Wassily Kandinsky, *Der Blaue Reiter*, 1903, private collection

CONNECTED EVENT

1893 – Henri Rousseau retires from his job as a tax collector in Paris to take up painting full time. His untutored 'primitive' style and dreamlike views of exotic jungles are an inspiration to many younger artists including Der Blaue Reiter group, the Surrealists and Pablo Picasso.

'0,10' EXHIBITION INTRODUCES SUPREMATISM
19 DECEMBER 1915,
ST PETERSBURG, RUSSIA

Although the wave of avant-garde artistic movements at the beginning of the twentieth century had rapidly moved away from showing a 'photographic' view of the world, the Cubists, Futurists, Expressionists and others still attempted to capture real things – houses, violins, horses – however much they transformed them.

Around the beginning of the First World War, several artists, including the Russian painter Kazimir Malevich, started to push the boundaries further. Malevich's new ideas on art, which he termed 'Suprematism', were first manifested in an exhibition in the city then called Petrograd, with the grandiose title 'The Last Futurist Exhibition of Paintings 0,10 (Zero Ten)'. Malevich was a mystic who believed art was essentially spiritual (much like Wassily Kandinsky, see page 122). The '0' in the title refers to the fresh beginning heralded by the new art, while the '10' marks the number of artists who were expected to take part in the exhibition.

Fourteen artists eventually showed work, including the prominent Russian artists Vladimir Tatlin and Liubov Popova. However, Malevich's contributions are what the show is now remembered for. His thirty-six paintings are made of simple squares, rectangles and circles, in monochrome blocks of colour. The most notorious is his first *Black Square* (1915) – a literal square of black paint on a white background. Malevich painted four versions of the *Black Square* – he described them as a 'zero', a starting point for a new form of non-representational painting. Malevich explained: 'To the Suprematist, the visual phenomena of the objective world are, in themselves, meaningless; the significant thing is feeling, as such, quite apart from the environment in which it is called forth.'

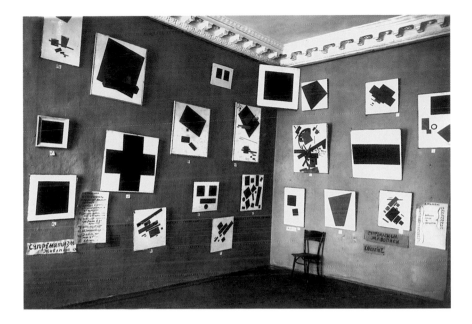

'0,10' exhibition
Installation view, 1915–16
Petrograd (now
St Petersburg)

This photograph focuses on part of Malevich's display: his *Black Square* was hung high in the corner of the room, in the place normally occupied in Russia by a religious icon.

Malevich was a pioneer of abstract painting and minimalism and greatly influenced mid-twentieth century art movements. His use of simple geometric shapes, like his fellow abstract painter Piet Mondrian, was taken up by Modernist architects and designers, and had a profound and enduring influence on the works of Iraqi-British architect Zaha Hadid.

KEY ARTIST

Kazimir Malevich (1878–1935), Russia

KEY ARTWORK

Kazimir Malevich, *Black Square*, 1915, The State Tretyakov
Gallery, Moscow, Russia

CONNECTED EVENT

Late 1919 – The Dutch painter Piet Mondrian begins making the
abstract paintings for which he is best known: blocks of primary
colours divided with thick black lines.

DUCHAMP'S *FOUNTAIN* IS REJECTED
10 APRIL 1917, NEW YORK, USA

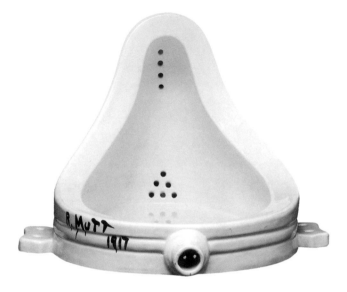

Once voted the most influential artwork of the twentieth century, the original of Marcel Duchamp's *Fountain* was only ever seen by a handful of people.

The French artist submitted it, under the pseudonym Richard Mutt, to the first exhibition of the Society of Independent Artists in New York. The society had been formed with the aspiration to democratize art – it had no jury or prize and bound itself to display any work submitted by an artist who paid the fee. Duchamp himself was on the board of directors and was head of the hanging committee; he had proposed that the artists' work be displayed in alphabetical order of their surnames, to avoid any one being prioritized over another. Despite this it seems he was keen to test the resolve of his colleagues and kept his authorship secret.

Fountain was one of Duchamp's 'readymades', in which he took an ordinary object and redesignated it as a work of art. A white porcelain urinal, it was turned by ninety degrees, with the signature

Marcel Duchamp
Fountain, 1917 (replica 1964)
Glazed earthenware, 36 x 48 x 61 cm (14¼ x 19 x 24 in.)
Tate Modern, London

Seventeen replicas of the lost original *Fountain* were made in the 1950s and 1960s and authenticated by Marcel Duchamp. They now sit in many major museum collections, including those of Tate and the Museum of Modern Art (MoMA), New York.

Alfred Stieglitz
Duchamp's Fountain
Photograph reproduced
in the avant-garde
magazine, *The Blind Man*,
May 1917

**This photograph is the
only record of the original
Fountain rejected by the
Society of Independent
Artists. The entry tag is
visible at the lower left.**

'R. Mutt' scrawled in black paint. During the installation of the exhibition, which opened on 10 April 1917, the society's directors took exception to the piece, reasoning that an item of sanitary ware could not be considered an artwork, and that it was indecent too. Breaking their own rules, they rejected the work from the show. In a later statement, the society argued: 'The *Fountain* may be a very useful object in its place, but its place is not in an art exhibition and it is, by no definition, a work of art.'

Duchamp resigned from the society in protest and recovered *Fountain* from the storeroom, taking it to be photographed by his friend Alfred Stieglitz. The work was later lost, perhaps thrown out as rubbish, so the photograph is the only record of the original.

The importance of the *Fountain* was defended in the second issue of the art journal *The Blind Man*, set up by Duchamp and his friends:

> Whether Mr Mutt with his own hands made the fountain has no importance. He CHOSE it. He took an ordinary article of life, placed it so that its useful significance disappeared under the new title and point of view – created a new thought for that object.

Fountain had no immediate impact, but it gained increasing fame in the 1950s and 1960s, as the new generation of conceptual artists saw in it the foundation of their own work. Duchamp had challenged the convention that a value of an artwork lay in the skill and effort of the artist – now an artwork could be anything. All of art today has to respond to this provocation.

KEY ARTIST
Marcel Duchamp (1887–1968), France

KEY ARTWORK
Marcel Duchamp, *Fountain*, 1917 (seventeen replicas made in the 1950s and 1960s)

CONNECTED EVENT
23 October 1993 – Musician Brian Eno claims he urinated on the replica of *Fountain* held at the Museum of Modern Art (MoMA) in New York, one of several attempts by various people to do so. Eno says he had to use a length of plastic piping to insert his liquid through the gaps in the glass case.

BRÂNCUŞI'S SCULPTURE *BIRD IN SPACE* IS SEIZED BY US CUSTOMS
OCTOBER 1926, NEW YORK, USA

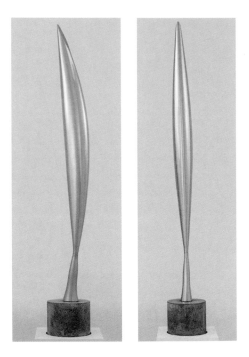

When US customs officials searched the crates that had arrived in New York on the steamship *Paris* in October 1926 they were baffled. The objects, accompanied by the controversial artist Marcel Duchamp (see pages 128–9), were supposed to be artworks. However, all they found were odd lumps of wood or stone, and a long, thin piece of shiny curved bronze that was called *Bird in Space*.

Constantin Brâncuşi was a Romanian-born sculptor whose works in the 1910s became ever more simplified and abstracted. His earlier sculptures of birds included recognizable heads, claws and beaks, but by 1923 he had eradicated any representation of a real bird, leaving only a metaphor for a bird's movement through the air. This was radical and new, and the customs officials refused to recognize it as an artwork. This was important because artworks incurred no tariff, whereas manufactured metal objects were taxed at forty per cent.

Constantin Brâncuși
Bird in Space
(two views), 1930s
Polished bronze on stone
bass, height 137.5 cm
(53 in.)
Peggy Guggenheim
Collection, Venice

**Brâncuși made several
versions of *Bird in Space*,
in marble and bronze.
The version that was
the subject of the court
case now resides at the
Seattle Museum of Art
in the USA.**

Brâncuși and Duchamp were outraged. The ensuing court case ran until the end of the following year. Brâncuși and his supporters had to prove that *Bird in Space* was a unique work of art. The sculptor testified to the time and care he spent polishing the bronze, and prominent art critics weighed in on his behalf. However, more traditional artists gave evidence for US Customs – one said that it was 'too abstract and a misuse of the form of sculpture'.

The judge decided for Brâncuși; his ruling said:

The object now under consideration . . . is beautiful and symmetrical in outline, and while some difficulty might be encountered in associating it with a bird . . . we hold under the evidence that it is the original production of a professional sculptor and is in fact a piece of sculpture and a work of art according to the authorities above referred to, we sustain the protest and find that it is entitled to free entry.

Abstract art was now officially recognized by the American law courts. But Brâncuși's problems with customs officials continued. In 1938 one of his carved stone sculptures was stopped by British officials due to a law protecting native stonemasons. They called in the director of the Tate Gallery, J. B. Manson, who was a painter himself and opposed to modern art. He declined to recognize the piece as an artwork, causing a storm that eventually cost him his job.

International conventions now standardize how art is treated by customs, but problems still occur, especially with sexualized imagery.

KEY ARTISTS
Constantin Brâncuși (1876–1957), Romania
Marcel Duchamp (1887–1968), France

KEY ARTWORK
Constantin Brâncuși, *Bird in Space*, 1926, Seattle Museum of Art,
Seattle, USA, and other bronze and marble versions elsewhere

CONNECTED EVENT
26 November 1878 – The painter James Abbott McNeill Whistler
wins his libel trial in London against the critic John Ruskin
who accused him of 'flinging a pot of paint in the public's face'
with one of his more abstract paintings. However, Whistler is
awarded only a farthing in damages and the costs of the case
bankrupt him.

PREMIERE OF *UN CHIEN ANDALOU*
6 JUNE 1929, PARIS, FRANCE

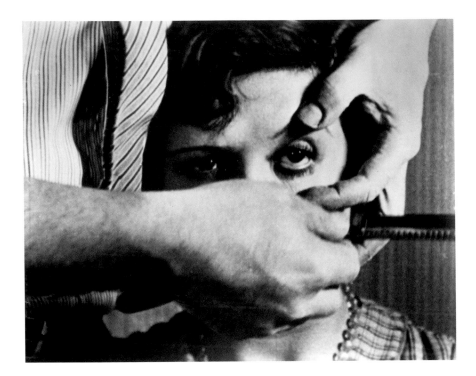

The director of *Un Chien Andalou*, Luis Buñuel, claims that he filled his pockets with stones before its premiere, in case his short film caused a riot. To the disappointment of his collaborator and fellow Spaniard, Salvador Dalí, it was received with acclaim and ran for eight months. Buñuel later said: 'What can I do about the people who adore all that is new, even when it goes against their deepest convictions, or about the insincere, corrupt press, and the inane herd that saw beauty or poetry in something which was basically no more than a desperate impassioned call for murder?'

Luis Buñuel
Un Chien Andalou, 1929
Black-and-white film,
silent, seventeen-minute
duration

The infamous eye-slicing shot was created using the eye of a dead calf. It was inspired by a dream of Buñuel's in which a cloud cut across the moon.

Un Chien Andalou is a black-and-white silent film. It is most famous for an early shot in which a man seems to slice the open eye of a woman with a razor blade, but the entire seventeen-minute film contains equally grotesque and inexplicable images: ants coming from a hole in a man's hand, a man dragging two pianos burdened with the corpses of donkeys and the woman's underarm hair appearing in place of the man's mouth. Despite the many attempts to decipher the film, Buñuel and Dalí were adamant that the images symbolized nothing and told no story. They are simply the random images of a fevered dream.

The premiere took place at the Studio des Ursulines, an experimental cinema in Paris that still operates today. In attendance were the leaders of the avant-garde, including Pablo Picasso, the architect Le Corbusier and the filmmaker Jean Cocteau. Most importantly the writer and poet André Breton and his circle of Surrealists were present. Dalí and Buñuel were immediately accepted into the group, which promoted just the use of dreamlike images and shocking juxtapositions shown in *Un Chien Andalou*.

While Buñuel continued a career as a film director, Dalí achieved even greater fame through his precisely detailed Surrealist paintings. *Un Chien Andalou*'s influence has been great, too. Financed by Buñuel's mother and edited on his kitchen table, the film is one of the earliest indie movies, while its shocking content has inspired horror movies and music videos. It is an early ancestor of modern arthouse cinema as well as the use of film by visual artists.

KEY ARTISTS
Luis Buñuel (1900–83), Spain
Salvador Dalí (1904–89), Spain

KEY ARTWORK
Luis Buñuel (director), *Un Chien Andalou*, 1929, available to view online

CONNECTED EVENTS
15 October 1924 – André Breton publishes his Surrealist manifesto, two weeks after a rival manifesto by Yvan Goll. Breton and Goll fought – including physically – over the rights to the term Surrealism with Breton emerging as the acknowledged leader of the movement.

THE NAZIS OPEN THE 'DEGENERATE ART EXHIBITION'
19 JULY 1937, MUNICH, GERMANY

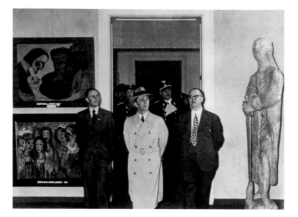

Between the wars, Weimar Germany was home to several influential avant-garde groups, including the Expressionist movement and the pioneering school of art and design, the Bauhaus. Many leading Nazis were enthusiastic about this homegrown Modernism, including the minister for propaganda, Joseph Goebbels.

Adolf Hitler – a failed painter himself – had different views. In 1934 he denounced modern artists as 'incompetents, cheats and madmen', and Goebbels was forced to fall in line. In order to save his position, Goebbels conceived of a show of art of which the Nazis disapproved, to run concurrently with the upcoming 'Great German Art Exhibition'.

A five-man committee toured German art museums, seizing over five thousand works they considered 'degenerate'. The exhibition opened in July in a venue specifically chosen for its cramped and dark rooms: 650 artworks were shown by over 100 artists, hung without labels and plastered with derogatory slogans such as 'An insult to German womanhood' and 'Madness becomes method'. It included works by German artists, such as Paul Klee, Franz Marc and Kurt Schwitters, and foreign artists, including Pablo Picasso, Piet Mondrian and Wassily Kandinsky.

One of the aims of the exhibition was to demonstrate the degenerate and subversive nature of Jewish art; ironically only a

'Degenerate Art Exhibition'
Berlin, 27 February 1938

Joseph Goebbels, the Nazi propaganda minister, organized the exhibition to curry favour with Adolf Hitler; here he views the version of the exhibition shown in Berlin.

handful of the artists were Jewish, while the artist with the greatest
number of works seized was a committed Nazi party member, the
the Expressionist painter and watercolourist Emil Nolde.

The exhibition was extremely popular, with as many as two million
visitors. The nearby exhibition of state-sanctioned art – noble
peasants and vigorous German youth – got only half as many views.
Alhough the works were meant to be destroyed after the show,
many were sold abroad to raise money for the Nazi war machine.

The Nazis' actions effectively brought the modern movement
in Germany to a sudden halt. Schools like the Bauhaus were closed
down, museum directors were replaced with Nazi sympathizers
and many of the proscribed artists fled to France, Britain and the
USA. Much of the production of early twentieth-century artists in
Germany has thus been lost.

KEY ARTISTS

Otto Dix (1891–1969), Germany
Paul Klee (1879–1940), Switzerland–Germany
Emil Nolde (1867–1956), Denmark–Germany

CONNECTED EVENT

February 2012 – Hundreds of works, seized by the Nazis or taken
from Jewish collectors in return for safe passage, are found
in Cornelius Gurlitt's squalid Munich apartment. Gurlitt was
the son of an art dealer who had claimed the works had been
destroyed during bombing in 1945.

Otto Dix
War Cripples, 1920
Black-and-white
photograph, original
painting presumed
destroyed

**Exhibited at the First
International Dada Fair in
1920, this painting shows
the heavy toll of the First
World War on the people
who fought in it. It was
shown in the 'Degenerate
Art Exhibition' with the
caption: 'Slander against
the German Heroes of
the World War.' It has not
been seen since.**

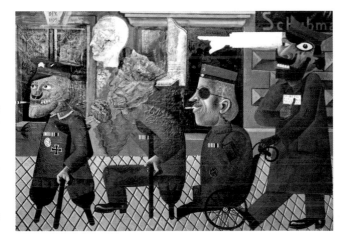

FRIDA KAHLO MEETS ANDRÉ BRETON
APRIL 1938, MEXICO CITY, MEXICO

In 1938 Frida Kahlo's paintings were beginning to be noticed but she was still overshadowed by the fame of her husband, Diego Rivera, one of the best-known and most successful artists in Mexico. They had married on 21 August 1929, when she was twenty-one and he was forty-two years old, and had had a fraught but intensely devoted marriage, punctuated by affairs on both sides.

The couple became increasingly involved in politics and in 1936 persuaded the Mexican president to grant asylum to the Russian revolutionary Leon Trotsky. Arriving on 9 January 1937 in Mexico, Trotsky and his wife were met by Kahlo who escorted them to her family home in Mexico City, where they lived for the next two years.

The presence of Trotsky in Mexico attracted worldwide attention, including that of the poet and leader of the Surrealists, André Breton, who had been sent to lecture in Mexico by the French Ministry of Foreign Affairs. He arrived in April 1938 and stayed for several months, some of the time with Kahlo and Rivera.

Breton was delighted with Kahlo, whom he saw as an instinctive Surrealist. He was especially interested in her recently completed painting *What the Water Gave Me* (1938), which shows Kahlo's toes peeking out of bath water, in which float dreamlike images from her life. Her bleeding and deformed right foot refers to the near-fatal injuries she received in a bus crash as a young woman.

Kahlo was not keen on Breton's categorization. 'They thought I was a Surrealist, but I wasn't,' she later said. 'I never painted dreams. I painted my own reality.' A later review concurred: 'While official Surrealism concerns itself mostly with the stuff of dreams, nightmares and neurotic symbols, in Madame Rivera's brand of it, wit and humour predominate.'

However, the association quickly led to increasing recognition. Breton wrote to his friend, the New York art dealer Julien Levy, who

Frida Kahlo
What the Water Gave Me, 1938
Oil on canvas, 91 x 71 cm
(35⅞ x 28 in.)
Private collection

Many of the images floating in the water derive from earlier paintings and relate to scenes in Kahlo's life.

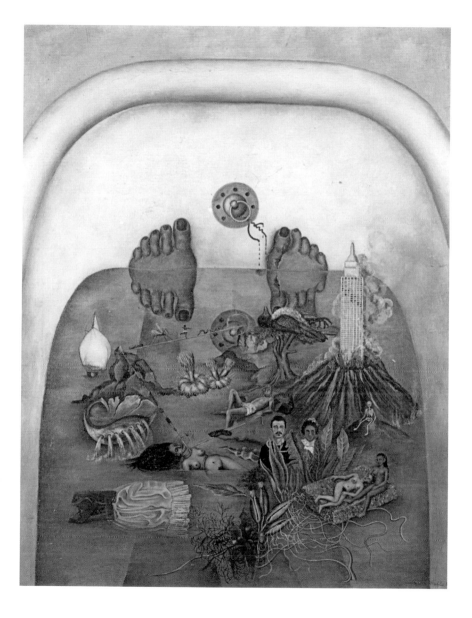

offered to hold Kahlo's first solo exhibition in October 1938. Her colourful Mexican dress caused a sensation and famous figures, including the painter Georgia O'Keeffe, attended the exhibition opening in November.

Next, Kahlo travelled on to Paris, where Breton had promised to hold a show of her work. She arrived to find that Breton had not cleared her works through customs and had no gallery in which to hold the exhibition. Frustrated, Kahlo quickly grew to loathe Breton and his circle, and Europe in general, as she wrote in a letter:

> You have no idea the kind of bitches these people [the Surrealists] are. They make me vomit. They are so damn 'intellectual' and rotten that I can't stand them any more . . . I bet you my life I will hate this place and its people for as long as I live.

Nonetheless Kahlo agreed to participate in the 'International Exhibition of Surrealism', which opened in Mexico on 17 January 1940, and in which she showed perhaps her most famous work *The Two Fridas* (1939; opposite, hanging on the studio wall). She was included in numerous group shows in Mexico and the USA over the following decade. Despite dying at the age of just forty-seven, Kahlo had established herself as one of the most famous and influential artists in the world.

Frida Kahlo's studio
Mexico City, c.1945

Kahlo is shown here with her husband, Diego Rivera, below her most famous work *The Two Fridas*.

KEY ARTISTS
Frida Kahlo (1907–54), Mexico
Diego Rivera (1886–1957), Mexico

KEY ARTWORKS
Frida Kahlo, *What the Water Gave Me*, 1938, private collection
Frida Kahlo, *The Two Fridas*, 1939, Museo de Arte Moderno, Mexico City, Mexico

CONNECTED EVENTS
17 September 1925 – Kahlo is severely injured in a bus crash. An iron handrail impales her through the pelvis and she fractures her ribs, legs and collarbone. While recuperating, she takes up painting, and many of her later works refer to her injuries and resultant inability to have children.

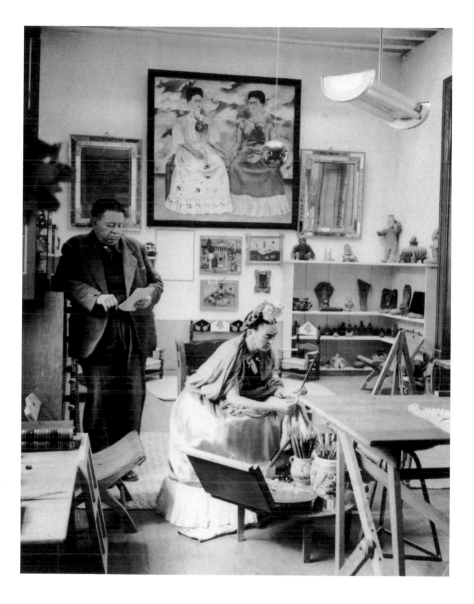

POST-WAR

-

They always say that time changes things,
but you actually have to change them yourself

-

Andy Warhol

1975

POLLOCK APPEARS IN
LIFE MAGAZINE
8 AUGUST 1949, NEW YORK, USA

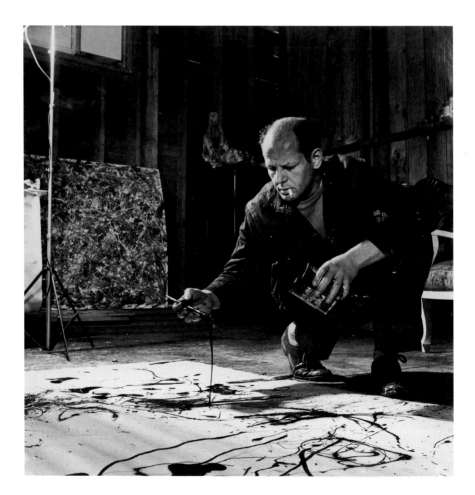

'Jackson Pollock: Is he the greatest living painter in the United States?' asked the headline under a photo of the artist posed insouciantly in front of a long painting filled with drips and splatters. Although the tone of the article was bemused (noting that the artist's neighbours entertained themselves by guessing what his paintings were supposed to represent), and the response of many readers was fury that Pollock's abstract paintings could be considered art at all, the fact that *Life* was even asking the question was significant. *Life* was America's premier image-led magazine, selling millions every week. It took an artist otherwise little known outside the New York art elite and made him into a national icon.

A black-and-white photograph included in the article became the defining image of Pollock (opposite). It shows him crouched over a canvas, paintbrush in hand, letting paint fall almost randomly in a composition that had no beginning or end. His style of painting was soon called 'Action Painting' after the reverie-like dance in which Pollock is supposed to have made his work.

The editors of *Life* were made aware of Pollock by the highbrow critic Clement Greenberg, whose opinion of him gave rise to the provocative question in the headline. For Greenberg, Pollock and his Abstract Expressionist peers were the beginnings of a new form of completely American art that had finally broken free of its European antecedents. Rumours that the CIA helped promote Pollock's art during the Cold War as a 'free art for free people' appear to be true; Pollock certainly quickly became one of the most famous artists of his generation and helped establish New York as the new hub of the post-war art world.

Martha Holmes
Jackson Pollock at work in his Long Island studio, New York, 1949
Gelatin-silver print, 40.6 x 50.8 cm (16 x 20 in.)
Private collection

This photograph of Pollock drizzling paint onto a canvas became an iconic depiction of the artist at work and was later made into a US postage stamp.

KEY ARTIST
Jackson Pollock (1912–56), USA

KEY ARTWORK
Jackson Pollock, *Summertime: Number 9A*, 1948, Tate Modern, London, UK

CONNECTED EVENT
11 August 1956 – Pollock crashes his car while driving under the influence of alcohol, killing himself and a friend, as well as severely injuring his mistress, Ruth Kligman. The pressure that came with his new-found success in the 1950s had exacerbated his alcoholism and he had not completed a painting since the previous year. He was only forty-four years old.

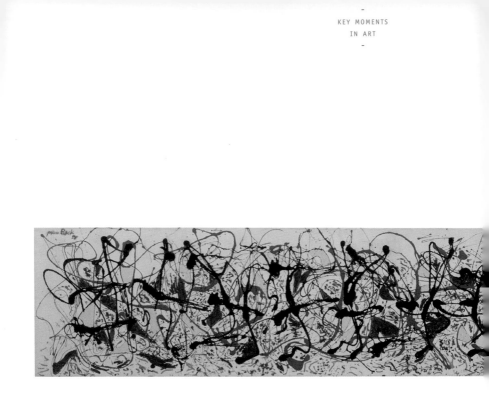

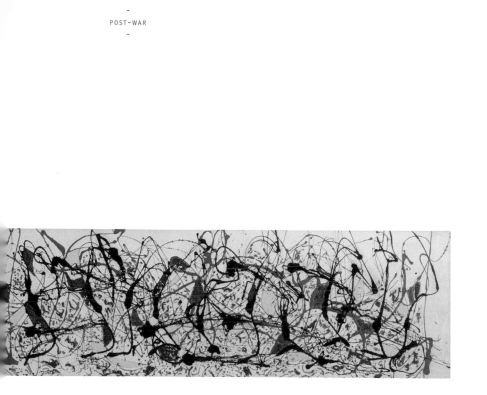

Jackson Pollock
Summertime:
Number 9A, 1948
Oil, enamel and house
paint on canvas, 84.8 x
555 cm (2¾ x 18¼ ft)
Tate Modern, London

This is one of the Pollock
paintings featured in
the *Life* article. Pollock
had started to number
his paintings to avoid
suggesting they were
intended to represent any
one thing.

RAUSCHENBERG ASKS DE KOONING FOR A DRAWING TO ERASE
LATE 1953, NEW YORK, USA

One evening in late 1953, the young artist Robert Rauschenberg
bought a bottle of Jack Daniel's whiskey and knocked on the
door of Willem de Kooning's studio. 'I hoped he wasn't at home,'
Rauschenberg remembered later. 'But he was.'

De Kooning was then at the pinnacle of the New York art world,
known for his abstract drawings and paintings based on the human
figure. Rauschenberg was a twenty-something up-and-comer, who
had received his artistic education at Black Mountain College in
North Carolina, which encouraged students to push the boundaries.

Rauschenberg asked de Kooning for one of his drawings, which he intended to take back to his studio and methodically erase, until nothing was left. Rauschenberg had been making a series of completely blank *White Paintings*, similar to the black squares of Kazimir Malevich (see pages 126–7). He wanted to create a drawing with the same aesthetic but was puzzled how to do it. At first he tried making a drawing himself, then erasing it, but realized this made the erasure only half the artwork, rather than the whole thing. He decided he needed to start with something made by another artist, and settled on de Kooning, with whom he had some contacts.

De Kooning was reportedly displeased by Rauschenberg's project but understood his idea. He selected a drawing that 'he would miss', but that would also be difficult to erase, containing ink and charcoal marks as well as pencil. Rauschenberg took over a month and numerous erasers to remove as much of the drawing as he could before having it framed. The explanatory label was made by his friend and fellow artist Jasper Johns.

Erased de Kooning Drawing was not shown publicly until 1963, but became much talked about by other artists, some of whom had seen it in Rauschenberg's studio. Some were excited by his work, while others felt it was an act of vandalism, destroying a potentially important artwork. *Erased de Kooning Drawing* is a forerunner to the conceptual art that flourished in the 1960s and 1970s. Its appeal is more intellectual than visual, embodying a laborious but ultimately arbitrary artistic process – an idea taken up in the performance art of Tehching Hsieh and Marina Abramović, among others.

Robert Rauschenberg
*Erased de Kooning
Drawing*, 1953
Traces of drawing media
on paper, with label and
frame, 64 × 55 × 1.3 cm
(25⅛ × 21⅞ × ½ in.)
San Francisco Museum of
Modern Art (SFMOMA),
San Francisco

**The frame and the
caption are an integral
part of this work that,
like much conceptual
art, is impossible to
decipher without an
understanding of the
process it has undergone.
No photographs exist
of de Kooning's original
drawing but an infrared
scan done by SFMOMA
in 2009 suggests it was
a sketch, with several
different human figures
in different places on
the paper.**

KEY ARTISTS

Robert Rauschenberg (1925–2008), USA
Willem de Kooning (1904–97), Netherlands

KEY ARTWORK

Robert Rauschenberg, *Erased de Kooning Drawing*, 1953, San
 Francisco Museum of Modern Art (SFMOMA), San Francisco, CA, USA

CONNECTED EVENT

August 1952 – John Cage organizes *Theater Piece No. 1* at Black
 Mountain College, Ashville – now considered to be the first
 Happening, a forerunner to Performance Art. Collaborating with
 the choreographer Merce Cunningham, the unscripted elements
 included Cage sitting on a stepladder and talking about
 Buddhism and Rauschenberg playing Edith Piaf records.

WARHOL PAYS $50 FOR AN IDEA
23 NOVEMBER 1961,
NEW YORK, USA

In 1961 Andy Warhol was struggling to find a unique and original subject matter for his art. He was already a successful and well-known commercial illustrator but his early attempts at making fine art – paintings that used popular cartoon characters such as Popeye and Mickey Mouse – were too similar to the works being made by Roy Lichtenstein, who had become famous for his comic strip-inspired paintings. The art dealer Leo Castelli refused to represent them both.

Pop art was an exciting new style pioneered by Lichtenstein, the sculptor Claes Oldenburg and British artists including Richard Hamilton. Instead of the serious and semi-mystical attitude towards painting of their immediate predecessors, the Abstract Expressionists, the Pop artists revelled in the glossy, meaningless world of mass consumerism.

One evening in November 1961, Warhol went to Oldenburg's latest show – soft, blown-up sculptures of burgers and ice cream. Annoyed he had not come up with the idea, Warhol visited a friend, Muriel Latow, an interior designer who also ran a struggling art gallery. 'It's too late for the cartoons,' said Warhol, according to his friend Ted Carey. 'I've got to do something that will have a lot of impact, that will be different from Lichtenstein . . . Muriel, you've got fabulous ideas. Can't you give me an idea?' Muriel replied she would, but it would cost Warhol $50. He wrote out a cheque and she asked him what he loved most in the world. 'Money.'

'Then you should paint pictures of that.' Warhol replied it was a great idea and did just that over the following year. Latow had one more idea: 'You should paint something that everyone sees every day, that everyone recognizes like a can of soup.'

The resulting paintings of Campbell's soup cans – thirty-two individual canvases, each representing a different variety – were first shown at the Ferus Gallery in Los Angeles on 9 July 1962 in Warhol's first one-man exhibition. Although the show started a debate within the art world, it was not commercially successful and only a few buyers paid $100 for one of the paintings, including film star Dennis Hopper.

Warhol's *Soup Cans* were shocking at the time and are still discussed and debated today. Following the lead of artists like Marcel Duchamp (see pages 128–9) and Robert Rauschenberg (see pages 146–7), Warhol had created artworks that seemed to remove the artist's touch, leaving appearance down to chance and industrial processes. Although many attempts have been made to understand their meaning, Warhol always maintained – deliberately deadpan – that he painted them simply because he used to eat soup every day for lunch. Rather than a critique of commercialism, they can be seen as a celebration of American culture, in which, as Warhol put it, 'the richest consumers buy essentially the same thing as the poorest,' where the president drinks the same Coke as the 'bum on the corner'.

KEY ARTISTS
Andy Warhol (1928–87), USA
Roy Lichtenstein (1923–97), USA
Claes Oldenburg (b.1929), Sweden–USA

KEY ARTWORKS
Andy Warhol, *Campbell's Soup Cans*, 1962, Museum of Modern Art (MoMA), New York, NY, USA
Andy Warhol, *Marilyn Diptych*, 1962, Tate Modern, London, UK
Roy Lichtenstein, *Look Mickey*, 1961, National Gallery of Art, Washington, DC, USA

Overleaf: Andy Warhol
Campbell's Soup Cans, 1962
Synthetic polymer paint on canvas, thirty-two canvases, each 51 x 41 cm (20⅛ x 16⅛ in.)
Museum of Modern Art (MoMA), New York

Warhol did not specify the order in which the Soup Cans should be displayed – they are normally shown in the order in which the flavours were introduced by Campbell's.

CONNECTED EVENTS
5 August 1962 – Marilyn Monroe dies of an overdose. The silkscreens Warhol makes of her over the following four months are displayed in a landmark show in New York in November 1962. This exhibition made Warhol's name as a major artist of the twentieth century.

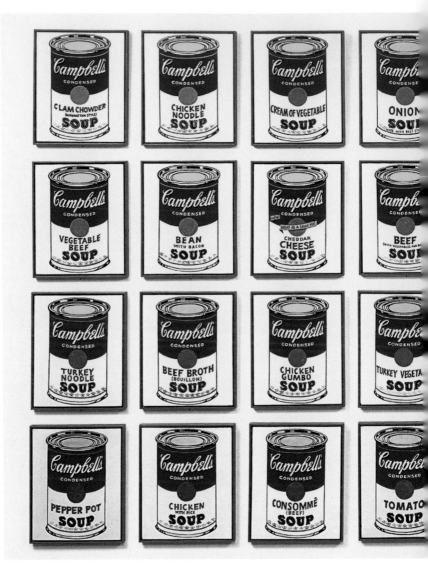

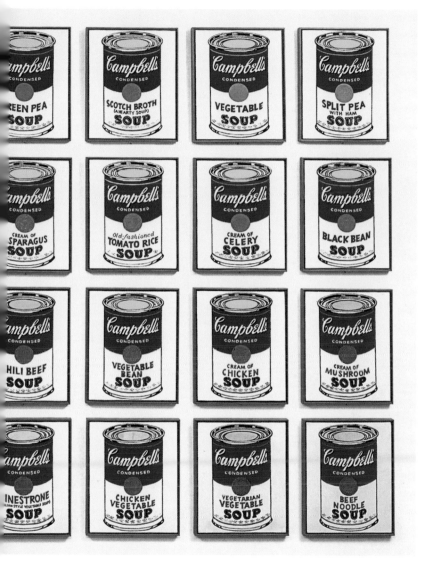

KUSAMA ORGANIZES A NAKED HAPPENING ON WALL STREET
14 JULY 1968, NEW YORK, USA

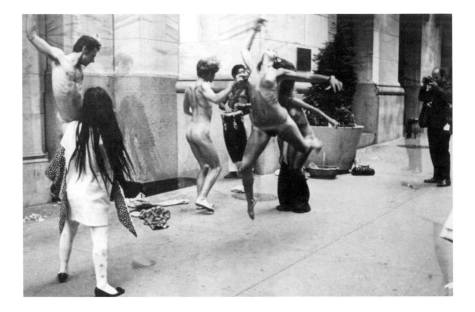

One bright Sunday morning in 1968, four young people, two men and two women, walked up to the New York Stock Exchange, stripped off their clothes and proceeded to dance and frolic to the beat of a congo drum. A gang of press photographers, who had been tipped off in advance, snapped enthusiastically as the Japanese-born artist Yayoi Kusama (herself fully clothed) directed the performance and painted polka dots on to the dancers' naked bodies. After a few minutes a look-out signalled the arrival of the police and the event, titled *Anatomic Explosion on Wall Street*, broke up.

Kusama had been living in New York for a decade, initially making abstract paintings and elaborate mirrored installations known as *Infinity Rooms*. In the late 1960s she began making films and performance pieces, and started organizing events she termed 'Happenings' or 'Orgies', combining naked dancing and political protest, primarily against the ongoing Vietnam War.

The first *Anatomic Explosion* was widely reported in the popular press and even in soft-pornographic men's magazines, which relished printing pictures of the nudity. Despite criticism from some art critics, who felt the events were self-indulgent stunts, Kusama was happy to get as much coverage as possible for her cause.

Over the next four months, further events were held at landmarks including the Statue of Liberty and the United Nations, culminating in an event in which Kusama distributed an open letter to the president, Richard Nixon, imploring him to bring the war to an end: 'Let us forget ourselves, dearest Richard, and become one with the Absolute, all together in the altogether . . . We'll paint ourselves with polka dots . . . and finally discover the naked truth: You can't eradicate violence by using more violence.'

The Happenings brought Kusama wide fame and she became synonymous in the public eye with the anti-war hippie culture. However, Kusama's health deteriorated and in the 1970s she returned to Japan, where she has remained since, living voluntarily in a psychiatric hospital. She is now regarded as perhaps the most influential living female artist.

Yayoi Kusama
*Anatomic Explosion
on Wall Street*, 1968
Performance

Kusama would issue press releases before her *Anatomic Explosions*, ensuring there would be photographers to record and publicize the events.

KEY ARTIST
Yayoi Kusama (b.1929), Japan

KEY ARTWORK
Yayoi Kusama, *Anatomic Explosion on Wall Street*, 1968, performance in New York, NY, USA

CONNECTED EVENT
25 March 1969 – The Japanese artist Yoko Ono and her new husband John Lennon stage a week-long 'bed in for peace' in an Amsterdam hotel. Each day they sit in the bed under signs reading 'Hair Peace' and 'Bed Peace' and speak to the press between 9am and 9pm.

BEUYS IS SHUT IN A GALLERY WITH A COYOTE
21 MAY 1974, NEW YORK, USA

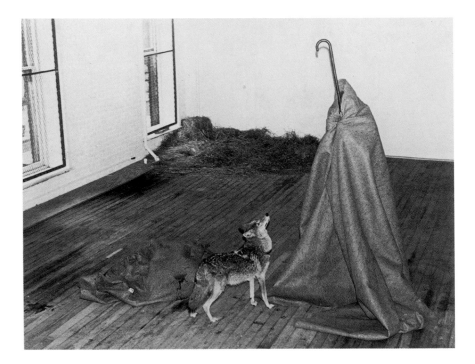

On arriving at New York's John F. Kennedy airport on 21 May 1974, the German artist Joseph Beuys was approached by two men, who wrapped him in felt and put him in the back of an ambulance. With sirens wailing, Beuys was driven to the René Block Gallery in Manhattan, where he was transferred directly into a room in which there was nothing but a bale of hay, a shepherd's crook, a pile of felt, fifty copies of the *Wall Street Journal* – and a live coyote.

This was the beginning of an influential three-day performance. Beuys was well known in European avant-garde circles, but this

work, titled with a touch of sarcasm *I Like America and America Likes Me*, introduced him to a wider audience. Beuys saw himself as a 'social sculptor', working in a wide variety of different media including drawing, sculpture, graphic design and performance. Many of his works reference his self-mythologizing account of his experiences of being shot down while flying for the Luftwaffe during the Second World War: Beuys claimed he was nursed back to health in Ukraine by Tatar tribesmen who wrapped him in felt and animal fats.

Joseph Beuys
I Like America and America Likes Me, 1974
Performance
René Block Gallery,
New York

Documents of the event, including photographs and posters, are now shown and collected as art works in themselves.

During the performance, Beuys gradually formed a relationship with the coyote, sometimes lying on the coyote's hay, sometimes wrapping himself in felt, with only the crook protruding. For Beuys, the coyote signified the oppressed indigenous people of America, some of whom revered the coyote before the colonialists killed them as a pest. After three days, Beuys was again put in the ambulance and taken back to the airport, seeing nothing of the United States except the room with the coyote.

Beuys saw art and politics as interwoven: he gave long lectures that were works of performance art in themselves, was a founder member of the German Green Party, and one of his last works was the planting of 7,000 oak trees in Kassel, Germany. His eclectic and often baffling work continues to have a large influence on contemporary artists, especially in the way he claimed utopian social projects as artworks.

KEY ARTIST
Joseph Beuys (1921–86), Germany

KEY ARTWORKS
Joseph Beuys, *I Like America and America Likes Me*, 1974, performance at the René Block Gallery, New York, NY, USA
Joseph Beuys, *How to Explain Pictures to a Dead Hare*, 1965, performance at Galerie Schmela, Düsseldorf, Germany

CONNECTED EVENT
26 November 1965 – Beuys puts on one of his earliest and most influential performances in a gallery in Düsseldorf, Germany: *How to Explain Pictures to a Dead Hare*. He locked himself inside the gallery with his head coated with honey and gold and spent three hours whispering to a dead hare cradled in his arms, describing the pictures in the gallery to it.

A PROTEST OUTSIDE MOMA LEADS TO THE FORMATION OF THE GUERRILLA GIRLS
14 JUNE 1984, NEW YORK, USA

In 1984, the prestigious Museum of Modern Art (MoMA) in New York held a major exhibition of 169 artists titled 'An International Survey of Recent Painting and Sculpture'. However, only thirteen of these artists were women and even fewer of them were black. A protest outside was largely ignored by the staff and visitors, so seven female artists decided a new approach was needed, as they describe on their website:

> We were shocked that no one visiting the museum seemed to care! That was the AHA! moment. There HAD to be a better way – a more contemporary, creative way – to break through people's belief that museums always knew best and there wasn't any discrimination in the art world.

Nine months later, the Guerrilla Girls were formed. They created and printed posters that raised the issue of sexism and racism in the art world in a direct, factual but light-hearted way, and pasted them around Manhattan. Their posters usually combine humour with revealing statistics, presented in bold black-and-white text. An early example listed how many exhibitions of female artists had been held at four major museums in the past year: just one.

As they became better known, the Guerrilla Girls started wearing gorilla masks to preserve their anonymity, inspired by a spelling mistake made by one of their members. They also assumed the names of important female artists from the past, such as Frida Kahlo and Käthe Kollwitz. Fifty more artists have been members of the group, some for just weeks, others for decades.

Since the 1980s the Guerrilla Girls have become largely accepted by the art establishment and their work is owned by many of the museums they have critiqued, including MoMA and Tate. However, they argue this allows them a bigger platform for their complaints. Most museums, for their own part, have taken the criticisms onboard and have striven to make their collections, displays and staff more diverse.

Mira Schor
Feminist demonstration
– The Women's
Artists Visibility Event
(W.A.V.E.), also known
as Let MoMA Know, 14
June 1984
Photograph taken outside
MoMA, New York

**The key members of the
Guerrilla Girls group
met during this protest
against the lack of
women artists
in a major exhibition of
contemporary painting
and sculpture at MoMA.**

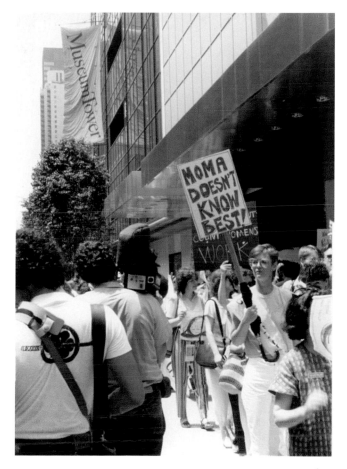

KEY ARTISTS
Guerrilla Girls (formed 1985), USA

KEY ARTWORK
Guerrilla Girls, *Do Women Have to Be Naked to Get into the Met.
Museum?*, 1989, screenprints in various collections worldwide,
including the National Gallery of Art, Washington, DC, USA

CONNECTED EVENT
10 May 1987 – Performance artist Suzanne Lacy directs an event
in a shopping centre in Minneapolis, USA. Four hundred and
thirty older women sat at tables and spoke about their lives,
broadcast live on television.

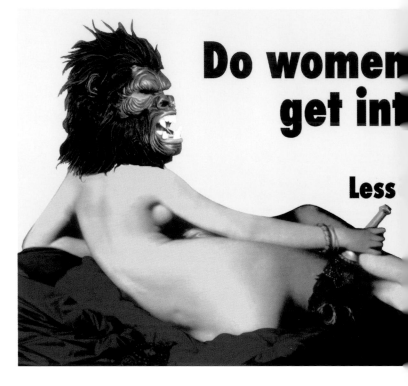

ve to be naked to
e Met. Museum?

% of the artists in the Modern
sections are women, but 85%
of the nudes are female

Statistics from the Metropolitan Museum of Art, New York City, 1989

GUERRILLA GIRLS CONSCIENCE OF THE ART WORLD

Guerrilla Girls
Do Woman Have to Be
Naked to Get into the Met.
Museum?, 1989
Screenprint on paper,
28 x 71 cm (11 x 28 in.)
Private collection

This is one of the
Guerrilla Girls' best-
known posters. Its
statistics are based on
a 'weenie count', where
members of the group
go to museums and count
the numbers of nude
men and women depicted
in the art.

THE EXHIBITION 'FREEZE' OPENS
6 AUGUST 1988, LONDON, UK

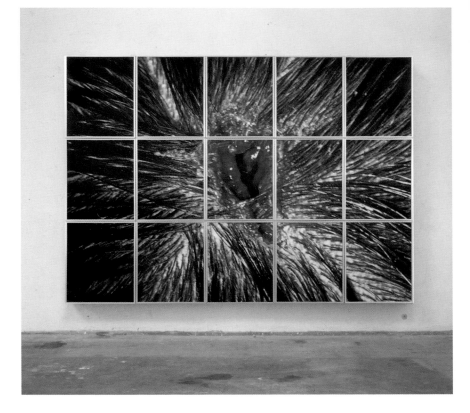

'Freeze' was an exhibition organized by a group of sixteen young British artists, many of whom were still at university. It was orchestrated by a second-year student at Goldsmiths College in south London – Damien Hirst.

It is common for art students to put on shows, but 'Freeze' was notable for its ambition and professionalism, driven by the entrepreneurial Hirst. The venue was an empty building in Surrey Docks, part of London's Docklands, which were then undergoing regeneration. Hirst gained sponsorship from a property developer, who also helped fund the lavish catalogue.

Hirst also took a proactive approach to promoting the show. He asked his tutors at Goldsmiths to ensure the attendance of influential art-world figures, such as Nicholas Serota, then head of the Tate galleries, and the collector Charles Saatchi. He even drove Norman Rosenthal, head of exhibitions at the Royal Academy, to the exhibition and back personally.

Many of the exhibitors were Hirst's fellow students at Goldsmiths, including Michael Landy, Fiona Rae, Anya Gallaccio, Gary Hume and Sarah Lucas. Although Hirst contributed some works to the show – such as two of his earliest spot paintings, painted directly onto the walls – the most memorable work in the exhibition was Mat Collishaw's *Bullet Hole*, a close-up photograph of a bloody wound blown up to a massive size. It not only demonstrated the 'shock value' for which the group would become known, but also the verve and self-confidence that helped them stand out, and their playful connections to the conceptual art of the 1960s.

The group quickly became known as the Young British Artists (YBAs), soon dominating the art scene in Britain and playing a key part in re-establishing London as an artistic centre. Most of the artists have gone on to have successful careers, but none is as financially successful as Hirst, who has become one of the world's richest living artists.

Mat Collishaw
Bullet Hole, 1988
Cibachrome mounted on fifteen light boxes, 229 x 310 cm (90⅛ x 122 in.)
Museum of Old and New Art, Hobart

Mat Collishaw was one of Damien Hirst's contemporaries at Goldsmiths. His *Bullet Hole* is a fragmented close-up of a head wound.

KEY ARTISTS

Damien Hirst (b.1965), UK
Sarah Lucas (b.1962), UK
Mat Collishaw (b.1966), UK

KEY ARTWORKS

Mat Collishaw, *Bullet Hole*, 1988, Museum of Old and New Art, Hobart, Australia
Damien Hirst, *Row*, 1988, and *Edge*, 1988, now destroyed

CONNECTED EVENTS

18 September– The exhibition 'Sensation' opens at the Royal Academy, London, before touring to Berlin and New York. It brings the YBAs to wider attention, including many artists who had exhibited in 'Freeze'.

15–16 September 2008 – Damien Hirst makes over £100 million by selling his work directly to collectors in an auction at Sotheby's called 'Beautiful Inside My Head Forever'. This was extremely unusual as art is normally first sold through galleries.

VAN GOGH'S *PORTRAIT OF DR GACHET* SELLS FOR A RECORD PRICE
15 MAY 1990, NEW YORK, USA

Before the late 1980s the most valuable paintings in the world were all Old Masters, mostly from the Italian Renaissance. The record price was $10.5 million for Mantegna's *Adoration of the Magi* (1462), bought by the J. Paul Getty Museum at Christie's auction house in London in 1985.

That record was shattered in March 1987, when Vincent van Gogh's *Vase with Fifteen Sunflowers* (1888) went for more than three times as much: $39.7 million. It was the first 'modern' painting to achieve such a high price and started a wave of speculation on Post-Impressionist paintings.

Many of these paintings were being bought by Japanese investors. Post-Impressionism was popular in that country, perhaps because of recognition of the influence of Japanese art on van Gogh and others. Another reason was Japan's booming real-estate market, and many of these paintings were becoming trading chips in complicated financial deals. The peak of the boom came on 15 May 1990, when Ryoei Saito, the honorary chairman of his family's paper firm, bought – apparently on a whim – van Gogh's *Portrait of Dr Gachet* (1890) at Christie's, New York. He paid $82.5 million and two days later spent nearly the same amount again on a painting by Auguste Renoir.

With the collapse of the Japanese real-estate market in the early 1990s, the profligate spending came to end and *Dr Gachet*'s record stood for over thirty years, taking into account inflation. Despite claiming, apparently jokingly, that he would have the painting cremated with him, Saito probably sold it on in the mid-1990s to cover his financial losses. The current owner and location of the painting are unknown.

The big sales of the 1980s radically changed the top of the art market. Although artworks had long been the prized trophies of states and aristocrats, now they are a new investment category, bought for their expected accumulation of value as much for their artistic worth.

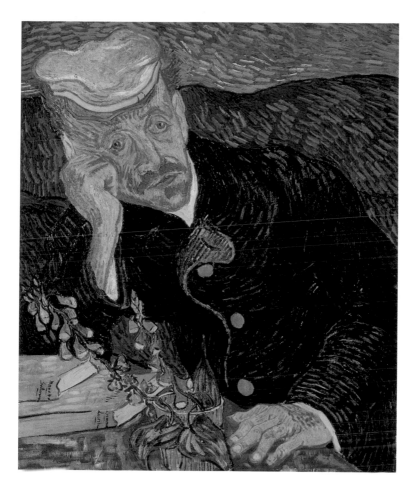

Vincent van Gogh
Portrait of Dr Gachet,
1890
Oil on canvas, 67 x 56 cm
(26⅜ x 22 in.)
Unknown location

**Dr Paul Gachet looked
after van Gogh in the
last few months of his
life. Gachet was a
painter himself and
had a special interest in
treating artists.**

KEY ARTIST

Vincent van Gogh (1853–90), Netherlands

KEY ARTWORKS

Vincent van Gogh, *Vase with Fifteen Sunflowers*, 1888,
 private collection
Vincent van Gogh, *Portrait of Dr Gachet*, 1890, private collection

CONNECTED EVENTS

27 July 1890 – Van Gogh shoots himself in the chest, dying thirty
 hours later, aged thirty-seven. Although not achieving success
 during his lifetime, his posthumous fame rose rapidly through
 exhibitions and the publication of his letters.

WHITEREAD'S *HOUSE* IS DEMOLISHED
11 JANUARY 1994, LONDON, UK

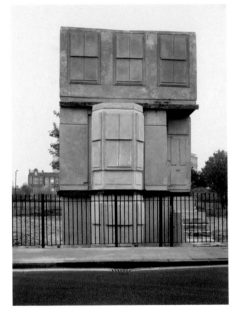

'It's not art, it's a lump of concrete,' explained the man tasked with tearing down Rachel Whiteread's short-lived sculpture, *House*, before jumping into his earthmover and crushing the concrete shell with a swipe of its claw.

House had always been meant to be temporary, but had attracted so much attention since it was completed just eleven weeks before, on 25 October 1993, that petitions had been collected and questions asked in Parliament in an attempt to save the work. It was not to be. The head of the local council hated the sculpture, describing it as a monstrosity, and ensured it was destroyed.

Whiteread had started her career by casting the spaces in and around domestic objects, before moving on to cast the interior of an entire room in concrete in *Ghost* (1990). The space was turned inside out, with the windows and fireplace evident as bulging shapes, the former home turned into a tomblike structure.

Rachel Whiteread
House, 1993
Concrete cast of interior of the terraced house at 193 Grove Road, London E3; destroyed 1993

House was located near Roman Road in East London, an area that was popular for artists' studios in the 1980s and 1990s but now is largely gentrified. Nothing remains of the sculpture: the wreckage was pulverized and buried on the site.

House was on an even bigger scale. Whiteread searched for a whole house she could cast, before finding a terraced house in East London that the council wanted to tear down to make way for a new park. Most of the residents of the terrace had moved out, but seventy-year-old ex-docker Sid Gale had refused, leaving his house standing proudly alone. The council agreed to lease it to Whiteread for a couple of months before it was finally destroyed.

Whiteread's team coated the interior with a special substance that covered all the cracks and then sprayed the walls with a thin layer of concrete. Further reinforced concrete was added, before the builders exited through the roof. Finally, the exterior walls, windows, doors and fittings were taken away, leaving just a ghostly impression of the home that once stood there.

House drew large crowds and divided opinion. Former owner Sid Gale was not pleased: 'All you can see is the lovely woodwork and mouldings the other way round. I had a lovely front room. I spent my life in it.' But others thought it was a seminal artwork. The art critic Andrew Graham-Dixon described *House* as a 'strange and fantastical object . . . one of the most extraordinary and imaginative public sculptures created by an English artist this century'.

The day 23 November 1993 was eventful for Whiteread. That night she was the first woman to win the Turner Prize, given by Tate to the outstanding British artist of the year. She was also given a prize by former pop group the KLF for the 'worst body of work over the past 12 months'. Earlier that same day, she had learned that the council had decided to demolish *House*. Since then, Whiteread has established herself as one of the world's most prominent sculptors.

KEY ARTIST
Rachel Whiteread (b.1963), UK

KEY ARTWORKS
Rachel Whiteread, *Ghost*, 1990, National Gallery of Art, Washington, DC, USA
Rachel Whiteread, *House*, 1993, demolished in London, UK
Rachel Whiteread, *Judenplatz Holocaust Memorial*, 2000, Vienna, Austria

CONNECTED EVENT
25 October 2000 – Whiteread's memorial to the Holocaust in Vienna takes the form of a concrete cast of a library; the unreadable books refer to the Jewish people who were killed.

ELIASSON BRINGS THE WEATHER INSIDE TATE MODERN
16 OCTOBER 2003, LONDON, UK

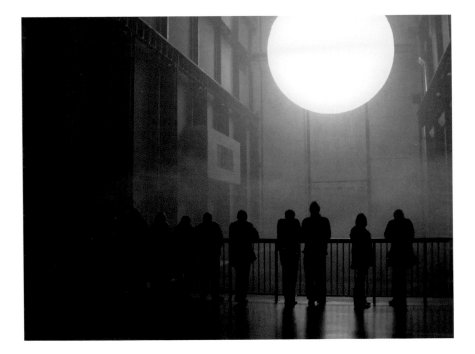

A visitor to London's recently opened art museum Tate Modern at the end of 2003 would have found an unusual sight. Despite the drizzle and dropping temperatures outside, inside people were lying on picnic blankets, bathing under the glow of an artificial sun, meeting, eating and chatting. Tate Modern's promise of being a new type of art museum was coming to fruition.

Tate Modern opened in 2000, one of the most prominent and successful of a new wave of art museums opened around the world in the 1990s and 2000s. Instead of being housed in a bespoke new building, Tate Modern took over a disused power station on the south bank of the Thames, and retained its old 'Turbine Hall' as a spectacular, cathedral-like space for new art commissions.

The Danish–Icelandic artist Olafur Eliasson had rapidly become known for his large-scale installations and artistic interventions, often using science and the natural environment to dazzle and amaze. He used strobe lights to turn bubbling water jets into stationary sculptures, he dyed rivers bright green and made an artificial geyser in another museum's courtyard. For *The Weather Project*, Eliasson covered the ceiling of the Turbine Hall with reflective foil, and then suspended a semi-circle of yellow lights at the far end of the hall. Machines pumped out a fine gauze of mist, giving the hall a balmy and mysterious atmosphere.

The enthusiastic response of visitors to the work exemplified the ambition of museums like Tate Modern to become a new kind of social space, similar to the agora of ancient Greece, where people can meet, converse and learn. Meanwhile, Eliasson's work is emblematic of a generation of artists working on a new scale, with new materials, who see themselves as creators of social situations as much as of objects.

Olafur Eliasson
The Weather Project, 2003
Monofrequency lights, projection foil, haze machines, mirror foil, aluminium, and scaffolding, 26.7 x 22.3 x 155.4 m (87⅞ x 73⅛ x 509⅞ ft)
Tate Modern, London

Eliasson's work was inspired by the British obsession with weather. When preparing this work, he sent questionnaires to Tate Modern staff members asking about how different weather conditions affected them.

KEY ARTIST
Olafur Eliasson (b.1967), Denmark–Iceland

KEY ARTWORK
Olafur Eliasson, *The Weather Project*, 2003, unique installation

CONNECTED EVENTS
18 October 1997 – The Guggenheim Bilbao is opened by King Juan Carlos I of Spain. With its spectacular building by architect Frank Gehry, the modern art museum bought wide attention to the post-industrial Spanish town and became a new model for economic and cultural regeneration.

-

**For the great doesn't happen through
impulse alone, and is a succession
of little things that are brought together**

-

Vincent van Gogh

1882

GLOSSARY

Abstract Expressionism: A form of painting developed in the United States after the Second World War by Jackson Pollock, Willem de Kooning, Mark Rothko and others, Abstract Expressionism often uses spontaneous, expressive gestures or canvas-filling blocks of colour.

Abstraction: Abstract art does not attempt to represent the world, but instead uses shapes, colours and forms. Little used in western art before the twentieth century, abstraction was a key development of modern art.

Academy: Established as art training schools during the Renaissance, academies began to dominate the production of art in Europe during the seventeenth and eighteenth centuries, often having a monopoly over the official art of their countries. They became increasingly conservative, and artists began to break away from them in the nineteenth century.

Art Nouveau: An international style of architecture and design that flourished at the beginning of the twentieth century. Its twisting, sinuous forms were inspired by flowers and plants.

Arts and Crafts: An anti-industrial design movement started in Britain by William Morris. The movement grew out of the Pre-Raphaelite artistic group and influenced later movements, such as Art Nouveau.

Avant-garde: Originally applied to the radical groups of artists in early twentieth-century Paris, avant-garde is now used to describe any art that is forward-looking or innovative.

Baroque: The dominant style of art and architecture in seventeenth-century Europe, which was less austere than the preceding Renaissance style. It developed into Rococo.

Classicism: Art that is inspired by or attempts to replicate the art and architecture of ancient Greece or Rome.

Conceptual art: Art focusing on ideas or processes rather than the finished objects. Conceptual art developed during the 1960s and 1970s.

Cubism: A highly influential art movement of the early twentieth century, developed by Pablo Picasso and Georges Braque, which attempted to depict objects from multiple perspectives simultaneously.

Dada: A left-wing movement formed in reaction to horrors of the First World War that created nonsensical and satirical art. Influenced the Surrealists and Conceptual artists.

Dutch Golden Age: A period broadly spanning the seventeenth century in which Dutch society, culture and industry underwent rapid growth and achieved unprecedented success and influence.

Expressionism: An artistic movement mainly centred in Germany in the early twentieth century, Expressionism used strong colours and distorted forms to express the artists' inner feelings. The two main groups were Der Blaue Reiter (The Blue Rider) and Die Brücke (The Bridge).

Frieze: A horizontal band of sculpted or painted decoration. In classical temples, the frieze is above the columns and is often highly decorated as shown by the Parthenon Marbles at the British Museum.

Futurism: An Italian art movement of the early twentieth century that aimed to capture the speed and energy of the modern world.

History painting: A grand painting showing a scene from history, classical myth or the Bible. History painting was considered to be the most prestigious form of art by most academies.

Iconoclasm: The desire to destroy works of art, usually for religious reasons.

Impressionism: A style of painting that was developed in France in the nineteenth century by Claude Monet and others. It attempted to capture fleeting visual impressions; the artists often worked quickly outdoors in front of the subject.

Mannerism: A sixteenth-century style of painting inspired by Michelangelo and Raphael, which focused on heightened elegance and artificiality.

Medieval: A period of history in Europe lasting from the end of the Roman Empire to around the beginning of the Renaissance in the fifteenth century. Although sometimes characterized as backward, art and architecture from this period was actually highly complex and was reassessed by artists in the nineteenth century.

Minimalism: A form of art that reduces objects to simple geometric shapes, particularly the sculpture made in the United States in the 1960s.

Modernism: Encompassing architecture, literature and music as well as the visual arts, Modernism was a broad cultural movement at the beginning of the twentieth century that rejected the styles of past and tried to find a new way of representing the modern world.

Neoclassicism: A purer, more historically accurate form of classicism that came about in the late eighteenth and nineteenth century as a result of greater knowledge of the ancient world. Commonly used for museum and law court buildings in Europe, the United States and elsewhere.

Old Masters: A group term for major European painters from before around 1800, who were commonly 'masters' of their local artists' guild and trained apprentices.

Pop Art: A style of art developed in the 1950s and 1960s, particularly in the Britain and the United States, which incorporated popular imagery such as comic books, advertisements and packaging.

Post-Impressionism: A term applied to late nineteenth-century painters including Vincent van Gogh, Paul Gauguin and Paul Cézanne, who advanced the Impressionist style, often making more subjective or emotional works. It was an important influence on later avant-garde styles including Cubism.

Pre-Raphaelites: A group of seven mid-nineteenth-century British artists and their associates. They advocated a more precisely painted and spiritually infused style of art that looked back to medieval religious art.

Realism: Art that attempts to accurately record an objective reality. As the name of a movement it refers to a group of mid-nineteenth

century – mainly French – artists who painted 'real-life' scenes of city life and country labourers.

Renaissance: A period of rapid artistic and scientific development in Europe from around 1400 to 1550, inspired by the achievements of the ancient world. The Italian Renaissance was centred in Florence, Venice and Rome and reached its peak in the art of Michelangelo, Leonardo da Vinci and Raphael. The Northern Renaissance saw the development of oil painting and the printing press.

Rococo: A highly decorative and whimsical style of art and architecture prevalent in eighteenth-century France and Germany.

Romanticism: An early nineteenth-century movement in art, literature and music, characterized by an interest in the expression of personal feelings and man's connection to the natural world.

Suprematism: A highly abstract style of art invented and promoted by the Russian painter Kazimir Malevich in the early twentieth century, featuring arrangements of simple geometric shapes in different colours.

Surrealism: A cultural movement from the mid-twentieth century that was interested in dreams and the unconscious.

INDEX OF ARTISTS

Illustrations are in *italics*.

PICTURE ACKNOWLEDGEMENTS

Front cover: Martha Holmes/The LIFE Picture Collection/Getty Images, © The Pollock-Krasner Foundation ARS, NY and DACS, London 2018; **2** Fine Art Images/Heritage Images/Getty Images; **8** Yulia Kreyd/Shutterstock.com; **12** © 2017 Opera di Santa Maria del Fiore/A. Quattrone/Photo Scala, Florence; **16** Leemage/Corbis/Getty Images; **17** ART Collection/Alamy Stock Photo; **25** Yulia Kreyd/ Shutterstock.com; **33** Courtesy National Gallery of Art, Washington, DC, Rosenwald Collection, 1964.8.697; **38** PjrTravel/Alamy Stock Photo; **40–41** photo © Rijkstudio; **48** Peter Greenhalgh (UKpix.com)/Alamy Stock Photo; **52** Photo © Rijkstudio; **57** Martin Bureau/ AFP/Getty Images; **59** Courtesy National Gallery of Art, Washington, DC, Rosenwald Collection, 1944.5.22; **64** Library of Congress/ Corbis/VCG/Getty Images; **70** © The Trustees of the British Museum; **72–3** © The Trustees of the British Museum; **80** US Patent Office; **89** Courtesy National Gallery of Art, Washington, DC, Harris Whittemore Collection, 1943.6.2; **91** Courtesy Library of Congress, Washington, DC; **95** Courtesy National Gallery of Art, Washington, DC, Gift of Mrs. John W. Simpson, 1942.5.10; **96** Photo © Philadelphia Museum of Art, Dist. RMN-Grand Palais/image Philadelphia Museum of Art; **99** akg-images/Laurent Lecat; **101** Courtesy National Gallery of Art, Washington, DC, Gift of the W. Averell Harriman Foundation in memory of Marie N. Harriman, 1972.9.5; **102** Courtesy The Metropolitan Museum of Art, New York, H. O. Havemeyer Collection, Bequest of Mrs. H. O. Havemeyer, 1929; **103** Ivoha/Shutterstock.com; **104** Collection Albright-Knox Art Gallery, Buffalo, New York, A. Conger Goodyear Collection, 1965, 1965:1; **108** Fine Art Images/Heritage Images/Getty Images; **113** © Succession Picasso/DACS, London 2018; **115** LaM, Lille Métropole musée d'art moderne d'art contemporain et d'art brut, Villeneuve d'Ascq, gift of Geneviève and Jean Masurel in 1979, © ADAGP, Paris and DACS, London 2018, photo © Philip Bernard; **118** The Metropolitan Museum of Art, New York, Bequest of Lydia Winston Malbin, 1989; **120** Chronicle/Alamy Stock Photo; **121** Roger-Viollet/Getty Images; **123** DeAgostini Picture Library/Getty Images; **127** Fine Art Images/Heritage Images/Getty Images; **128** © Association Marcel Duchamp/ADAGP, Paris and DACS, London 2018; **129** © Association Marcel Duchamp/ADAGP, Paris and DACS, London 2018; **130** © Succession Brancusi – All rights reserved. ADAGP, Paris and DACS, London 2018; **132** © Salvador Dalí, Fundació Gala-Salvador Dalí, DACS 2018, photo: Granger Historical Picture Archive/Alamy Stock Photo; **134** akg-images; **135** © DACS 2018, photo: dpa picture alliance/Alamy Stock Photo; **137** © Banco de México Diego Rivera Frida Kahlo Museums Trust, Mexico, D.F./DACS 2018; **139** © Banco de México Diego Rivera Frida Kahlo Museums Trust, Mexico, D.F./DACS 2018, photo: Hulton Archive/Getty Images; **140** © Guerrilla Girls and courtesy of guerrillagirls.com; **142** Martha Holmes/The LIFF Picture Collection/Getty Images; © The Pollock-Krasner Foundation ARS, NY and DACS, London 2018; **144–5** © The Pollock-Krasner Foundation ARS, NY and DACS, London 2018; **146** © Robert Rauschenberg Foundation/DACS, London/VAGA, New York 2018; **150–51** © 2018 The Andy Warhol Foundation for the Visual Arts, Inc./Artists Rights Society (ARS), New York and DACS, London; **152** © Yayoi Kusama, photo by Michael Benedikt; **154** © DACS 2018, photo: Caroline Tisdall; **157** Photo: Mira Schor; **158–9** Copyright © Guerrilla Girls and courtesy of guerrillagirls.com; **160** © Mat Collishaw. All Rights Reserved, DACS 2018; **164** © Rachel Whiteread. Courtesy of the artist and Gagosian. Photo: Sue Omerod; **166** Courtesy of the artist, photo: Susan May

-

To Daniel and Sam

-

First published in the United Kingdom in 2018 by Thames & Hudson Ltd, 181A High Holborn, London WC1V 7QX

Key Moments in Art © 2018 Thames & Hudson Ltd, London Text © 2018 Lee Cheshire

Design by April Edited by Caroline Brooke Johnson

All Rights Reserved. No part of this publication may be reproduced or transmitted in any form or by any means, electronic or mechanical, including photocopying, recording or any other information storage and retrieval system, without prior permission in writing from the publisher.

British Library Cataloguing-in-Publication Data

A catalogue record for this book is available from the British Library. ISBN 978-0-500-29362-1

Printed and bound in China by Toppan Leefung Printing Ltd

To find out about all our publications, please visit **www.thamesandhudson.com**. There you can subscribe to our e-newsletter, browse or download our current catalogue, and buy any titles that are in print.

Front cover: Martha Holmes, *Jackson Pollock at work in his Long Island studio, New York*, 194 (detail from page 142) © The Pollock-Krasner Foundation ARS, NY and DACS, London 2018

Title page: Gustav Klimt, *Beethoven Frieze*, 1901–2 (detail from page 49). Secession Building, Vienna

Chapter openers: page 8 Michelangelo, *David* (replica), 1501–4 (detail from page 25). Palazzo Vecchio, Florence; **page 36** Caravaggio, *David with the Head of Goliath*, c.1610 (detail from page 47). Galleria Borghese, Rome; **page 68** Vincent van Gogh, *Bridge in the Rain* (after Hiroshige), 1887 (detail from page 93). Van Gogh Museum, Amsterdam; **page 110** Franz Marc, *Blue Horse I*, 1911 (detail from page 125). Lenbachhaus, Munich; **page 140** *Guerrilla Girls Review The Whitney*, 1987. © Guerrilla Girls and courtesy of guerrillagirls.com.

Quotations: page 9 Giorgio Vasari, *Lives of the Artists*, vol. 1, page 632 (Everyman's Library classic edn, London 1996); **page 37** Transcript of Paolo Veronese's interrogation by the Inquisition: http://www.eyewitnesstohistory.com/inquisition.htm; **page 69** Van Gogh's letter to Theo, January 1874: http://vangoghletters.org/vg/letters/let017/letter.html; **page 111** Wassily Kandinsky and Hilla Rebay, *On the spiritual in art* (Solomon R. Guggenheim Foundation, New York, 1946); **page 141** *The Philosophy of Andy Warhol*, https://books.google.co.uk/books?id=utihBQAAQBAJ&pg=PT124&dq=philosophy+of+andy+warhol+'they+always+say+time+changes+things'; **page 168** Van Gogh's letter to Theo, 22 October 1885, http://vangoghletters.org/vg/letters/let274/letter.html